VELÁZQUEZ

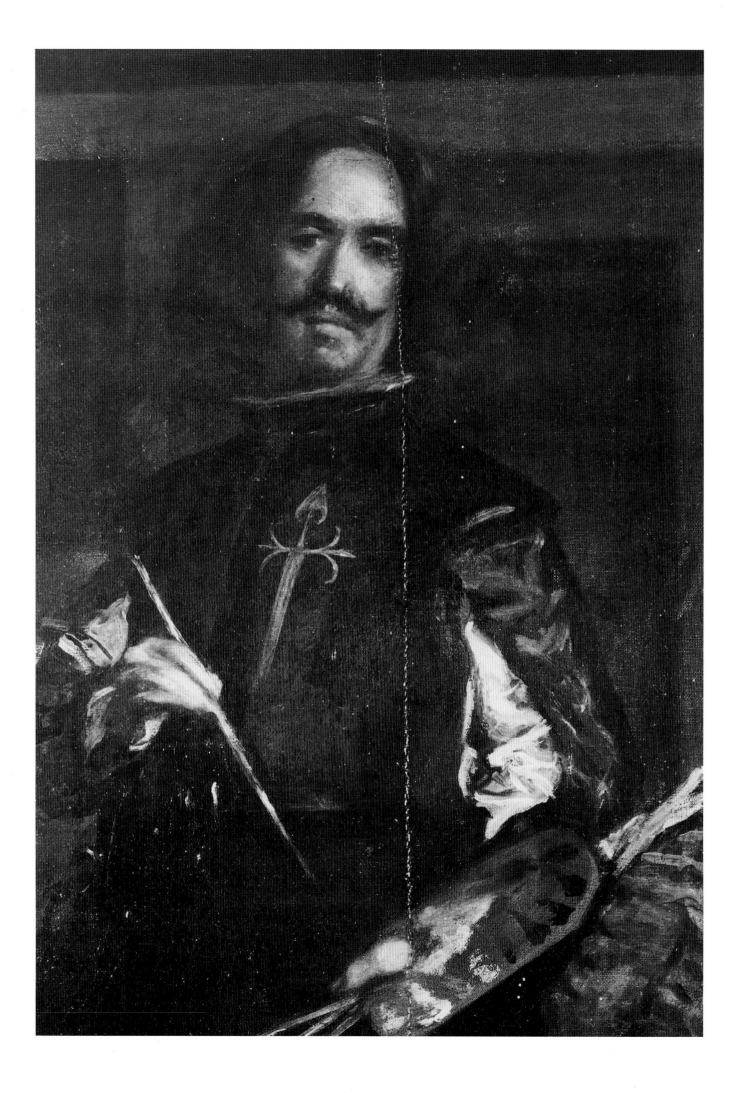

VELÁZQUEZ

Text by

MAURICE SÉRULLAZ

Curator-in-Chief of the Cabinet des Dessins, Musée du Louvre, Paris

with the collaboration of Christian Pouillon

HARRY N. ABRAMS, INC., *Publishers*, NEW YORK

Translated from the French by
I. MARK PARIS

Frontispiece:
THE MAIDS OF HONOR (LAS MENINAS),
detail 1656. Oil on canvas, 10′5½″ × 9′1″.
Museo del Prado, Madrid.
See page 116 for commentary.

Library of Congress Catalog Card Number: 86-72000

ISBN 0-8109-1729-7

Illustrations copyright © 1981 Harry N. Abrams, Inc.

Published in 1987 by Harry N. Abrams, Incorporated, New York
All rights reserved. No part of the contents may be reproduced
without the written permission of the publishers

All reproductions from the Museo del Prado, Madrid,
copyright © by the Museo del Prado, Madrid. All rights reserved.

Times Mirror Books

Printed and bound in Japan

CONTENTS

D D Velasquez

"What I call 'Great Art' is simply art that requires that a man exercise all of his creative faculties, and whose works are such that all the faculties of another are called upon and become irresistibly involved in understanding these works. . . . For my part, I believe it matters a great deal that a work of art be the act of a complete man."

PAUL VALÉRY
(*Degas Dance Drawing*)

History identifies the figure of the painter at work in *Las Meninas* (*The Maids of Honor*) (frontispiece and colorplates 35, 36) as a self-portrait of Velázquez decorated with the cross of the Order of Santiago. Without minimizing the importance of the representation of an "individual," we should still like to question the presence of the "painter character" who himself strikes a pose.

Among the many interpretations of this highly complex, dichotomous, almost paradoxical painting, there are two paths open to us to guide us toward understanding its overall meaning. The first signal, provided by the figure, is an assertion of reality that is confirmed by the existence of the painter, as if to say: "I was there, and here is the accurate reflection of what I saw." The second signal is that of Art, which is unable to reduce itself to a mere eyewitness account, and whose importance is contained in the warning "Look out, Painting!" Neither of these approaches lacks for simple, clear-cut historical and aesthetic points of reference, explicitly revealed in the painting itself. On the one hand, the fact that Velázquez occupies a place among the members of Philip IV's family adds the honor of acknowledged royal friendship to his duties as official portraitist. But at the same time, this privileged spectator who is the artist, and the actual scene of the Infanta Margarita and her maids of honor, are all surrounded by an array of pictures. Included among these are not only the stretcher of the canvas in the foreground, but also the three works behind the painter and his models: namely, two large paintings after Rubens and Jacob Jordaens (not at all unrelated to other paintings by Velázquez), and, the most ambiguous of all the images, the

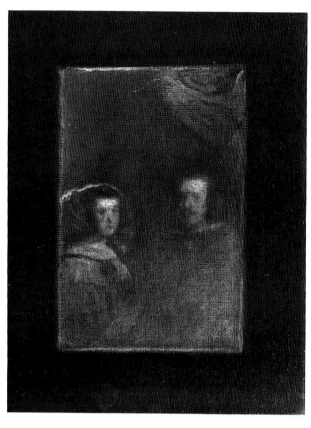

I. THE MIRROR WITH THE KING AND QUEEN, detail of THE MAIDS OF HONOR (LAS MENINAS). 1656. Oil on canvas (complete work 10' 5 1/2″ × 9' 1″). Museo del Prado, Madrid

royal couple reflected in the mirror picture, who are thus models as well as onlookers. Although blending these elements is no easy matter, they are basically not all that irreconcilable. Nothing prevents us from considering the problems posed by this kind of painting—a work in which figures predominate—as those of a figurative activity that questions reality in order to better authenticate the truth.

The ambiguities in *Las Meninas* constitute but one impressive example among many such plays upon glances, reflections, and mirrors. *The Spinners* (colorplates 37, 38) would serve as a prime example of the response of Art to the theme of a realistic scene, by joining together disparate elements and treating a subject on two different levels. Even the simplest of paintings utilizes these haunting motifs. Do such skillful but unfathomable tableaux confirm that the world is only a dream? Or that painting is a mirage? Or that *both* of them stem from a double illusion? And are they, as a result, reconnected by an intellectually Baroque point of

view? It seems to us instead that treatises on painting state firmly that painting has a role to play within the real world. It is in this sense that one thing is of utmost importance: the constant impression that the model is, in fact, posing, with eyes turned toward us, the painter, or another spectator; though less remarkable in the portraits per se, the effect does occur frequently in the large works. This element is curiously missing from Velázquez's traditional religious scenes, which reflect an artist who has not yet come into his own. Only in paintings of his later years can this phenomenon be clearly perceived.

However, the seductive "double" mirror is meant to be only a starting point; it is not offered as a pictorial end in itself. What is involved is a process of calling attention to—not blotting out—the artifices of composition with a force of conviction that, far from making art and reality compromise each other, attests to their relationship in an extraordinarily confident way. For both the central and peripheral themes—that covered both the right and reverse sides of its paintings—Spain in its Golden Age turned again to its most disturbing subject matter for entertainment. These works, which included poetic polysemy (multiplicity of meaning), were seen not as an opportunity to diverge from reality, but, rather, to assert its existence, as well as that of painting itself. This leads to a convergence of thought and feeling in the treatment of forms that reflects the repertory of the universe; a convergence which may even be applied to the forms and techniques passed down from traditional European painting, assuming such a heritage indeed exists. This force of conviction should be called Realism, in the sense of a fundamental belief and confidence in reality.

This Realism was based on keen observation of people and objects, even the most humble and commonplace (allowing that life at court, too, can become commonplace). In their aesthetic classifications, Velázquez's contemporaries—his teacher and father-in-law, Francisco Pacheco; Vicente Carducho; and Jusepe Martínez—focused on the fundamental aspect of this initial faithfulness to reality: they categorized him among those painters who imitated nature. Nature, as a subject for the

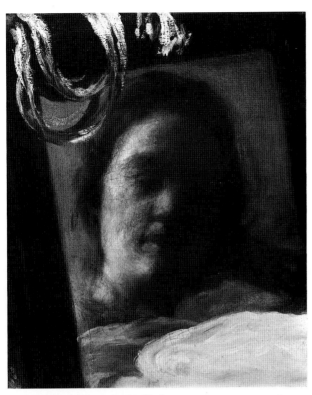

2. HEAD IN THE MIRROR, detail of THE TOILET OF VENUS. c. 1649–50. Oil on canvas (complete work 48 1/4 × 69 3/4″). *National Gallery, London*

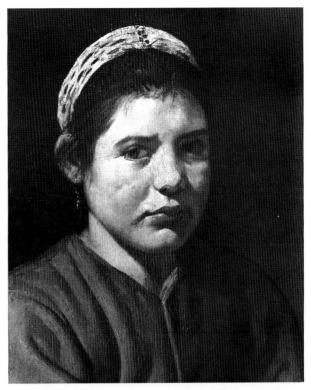

3. YOUNG SERVANT, detail of CHRIST IN THE HOUSE OF MARTHA AND MARY. c. 1618. Oil on canvas (complete work 23 5/8 × 40 3/4″). *National Gallery, London*

art of illusion, reflected the contrasts of contemporary Spain that existed between individuals as well as customs. In no way did this art shy away from what Eugène Delacroix, in a nineteenth-century polemic against the Realists of his day, was to call "the cruel reality of things." Credit for this must be given to the impetus provided by the various movements descended from Caravaggism early in the seventeenth century, a movement with a special lesson to offer a country where the popular figural type was a well-known object of attention. In fact, the new aesthetic expressed itself in religious paintings throughout Counter-Reformation Europe: religious themes were undisguisedly reworked using figures drawn from life, and the models were often selected from among the masses. We should note, however, that Velázquez was as revolted by the trivial as by the anecdotal and the picturesque, whereas a gallery of figures from all walks of life corresponded, for him, to the significance and function of those objects that represented and thus defined the people of a

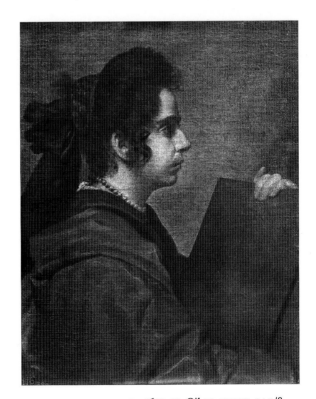

4. A WOMAN AS A SYBIL. 1631–32. Oil on canvas, 24 3/8 × 19 3/4″. *Museo del Prado, Madrid*

9

wretched, wasteful land. It was a land whose prosperity was faltering, and whose people were battling fate with all the resources of their souls, their feeling for life and for their time, their sense of destiny, and even their resignation.

It is known that Velázquez, although apparently so reserved in temperament, was nevertheless desirous of honors and gratuities. From these he derived not only profit, but the relative freedom to largely extricate himself from the restraints of official art (while at the same time enjoying the royal protection and the weighty duties it entailed). Gradually liberated from various aesthetic constraints, even once within the "inner circle" at court, his style evolved by adapting itself to the visual material furnished by his successive positions—first as an artist experienced in the genre of the *bodegón* and the *pícaro* (which he was never to completely abandon), then as Painter to the king.

The tangible world is an inexhaustible source of inspiration for an artist. Instead of expressing the lyrical sides of suffering, Velázquez seemed to focus his unerring eye on a human microcosm alternately impoverished yet stiffly formal, nostalgic yet provocative—with equal sensitivity for the vitality of the humblest beggars, the toil of artisans, the multifaceted personality of Philip IV, and the suffering of both the court jesters and the royal children in their suffocating surroundings. Lucidity is more far-reaching than pity.

The best way to assess the role played by this original strain of Realism is to neatly categorize those genres of painting most characteristic of the time. Religious painting again serves as a highly significant case in point. Until *The Coronation of the Virgin* (c. 1641–44; colorplate 26), works of this sort, for all their plastic interest, were highly traditional in terms of iconography: they are less striking than those few scenes of "miracles" in which plausibility seems a matter of utmost and scrupulous necessity, rather than the result of an inability to render the supernatural. "If he [Velázquez] didn't paint angels," observed the Romantic

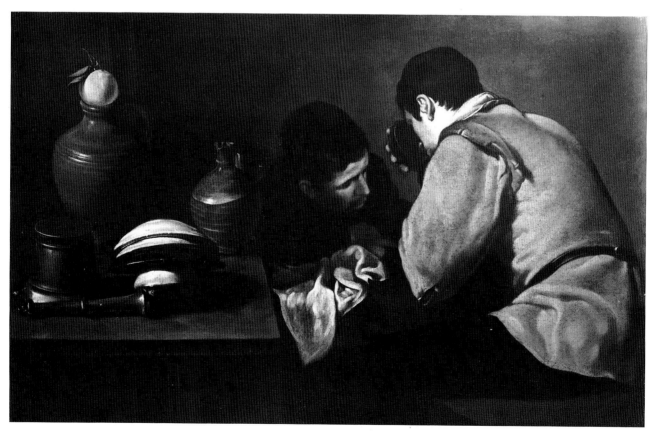

5. TWO YOUNG MEN AT TABLE. C. 1618–22. Oil on canvas, 25 3/8 × 40 7/8″. *Wellington Museum, Apsley House, London*

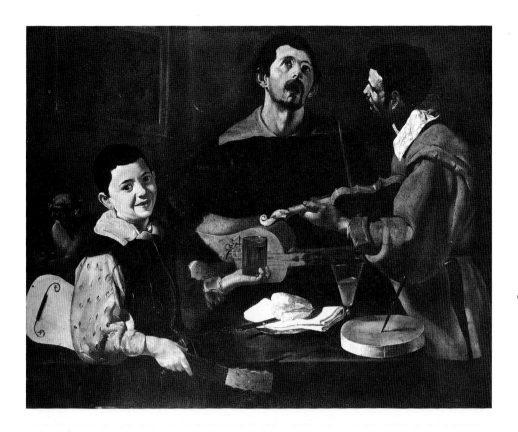

6. MUSICAL TRIO. C. 1617–18. Oil on canvas, 34 1/4 × 43 1/4″. *Staatliche Gemäldegalerie, Berlin-Dahlem*

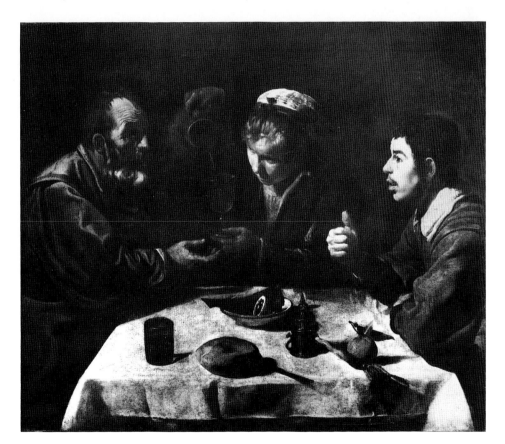

7. A GIRL AND TWO MEN AT TABLE. C. 1618–20. Oil on canvas, 37 7/8 × 44 1/8″. *Museum of Fine Arts, Budapest*

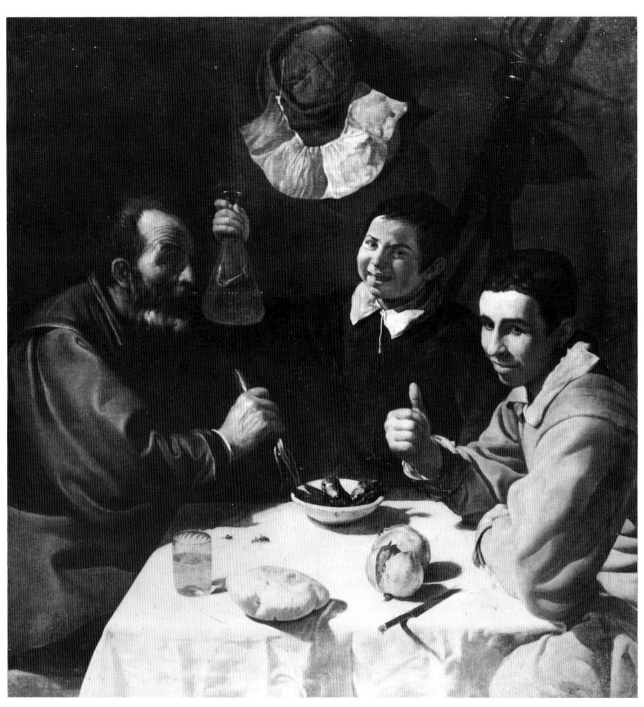

8. THREE MEN AT TABLE. C. 1617–18. Oil on canvas, 42 1/8 × 39 3/4″. *The Hermitage, Leningrad*

art critic Théophile Gautier, "it is because they did not pose for him." In one of the earliest of these scenes, *Christ in the House of Martha and Mary* (c. 1618; colorplates 2, 3), we are presented with a domestic tableau ostensibly depicting culinary advice, but the painting's true subject, the religious event, is reflected in the mirror in the background. The spectator experiences a scene from everyday life and, at the same time, an act of faith in all its subjective ramifications, both encompassed in a single canvas.

These skillful paintings, with their elaborate visual tricks and extensions of the space of the composition, cause us to reflect upon reality and truth. If they are somewhat lacking in religious inspiration, the artist makes up for this—up until the end of his career—by drawing upon mythological sources, sometimes as pretexts for his subject matter. A typical example of this approach is *The Forge of Vulcan* (1630; colorplates 13, 14). Apollo's dress and appearance are extraordinary indeed among the blacksmiths at the village forge; these rough workers seem to be astounded by Apollo's unlikely presence and almost appear to mock this unearthly apparition. The

contrast of two light sources heightens the effect of the "outside" sunburst of light that surrounds the god—removed, here, from his usual Olympian setting. (Although Apollo is painted without muscles, the familiar glimmer from the forge models the bodies of the other, mortal figures.) However, this aesthetic, iconographic, and technical pastiche, though it does have a kind of surreal quality, is more than just an exercise in make-believe. In all likelihood, Velázquez regarded imagination as a creative faculty infinitely rich in forms and ways of depicting light, capable of overturning the realities of nature and mankind alike. The position of the observer takes on a deeper meaning in this kind of painting. It helps explain the Impressionists' admiration, in the nineteenth century, for an art that could reconstruct sensation through realistic effects of light and which foreshadowed Toulouse-Lautrec's declaration: "I want to create truth, not the ideal."

Now we can understand why paintings of historical subjects do not provide opportunities for creations of epic proportions. In *The Surrender of Breda* (1634–35; colorplates 19, 20), war and its drama are reduced, as far as imagery is con-

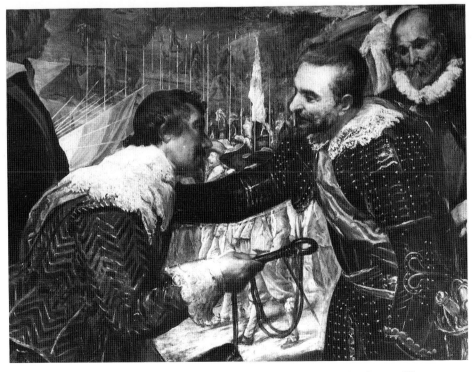

9. SPÍNOLA AND NASSAU, detail of THE SURRENDER OF BREDA (LAS LANZAS). 1634–35. Oil on canvas (complete work 10′ 1 1/8″ × 12′ 3/4″). *Museo del Prado, Madrid*

cerned, to oversimplification, if not downright banality, in the same spirit as the series of *bodegones*. An event of historical and political importance is depicted, unrealistically, as merely a human gathering, devoid of loftiness, grandiloquence, or even heroic expressiveness. For those who are concerned as observers, the very best one can say is that the men are presented sincerely and believably. And the loyalty we attribute to them is echoed in a pictorial loyalty to an event that affected the lives of individuals and the public, reconstructed by an artist who interprets and arranges in a single composition a group of figures surrounded by objects of special significance—in this case, the lances.

But in the final analysis, when we think of the art of Velázquez, it is the portraits that come readily to mind. Peerless in their originality, Velázquez's portraits—for him both the principal means and end of artistic expression—presuppose a psychology, if not a philosophy of truth and life. There is no sure answer to the question of how much of an artist's personal intentions he ultimately infuses into a likeness of his model; how much of his own feelings and experiences, his notions of life and time, of the individual versus society and the universal versus the particular, he allows to influence his artistic vision. Moreover, the task of the artist is an obvious and a twofold

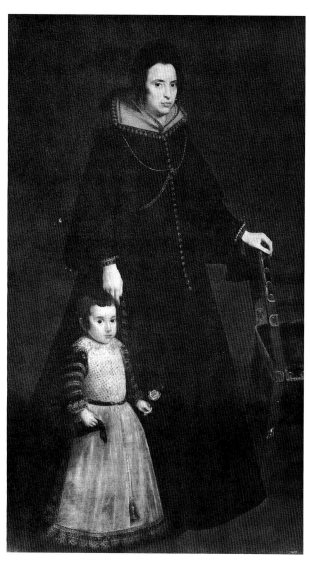

10. DOÑA ANTONIA DE IPEÑARRIETA Y GALDÓS AND HER SON LUIS VELÁZQUEZ. 1631–32. Oil on canvas, 84 5/8 × 43 3/8″. *Museo del Prado, Madrid*

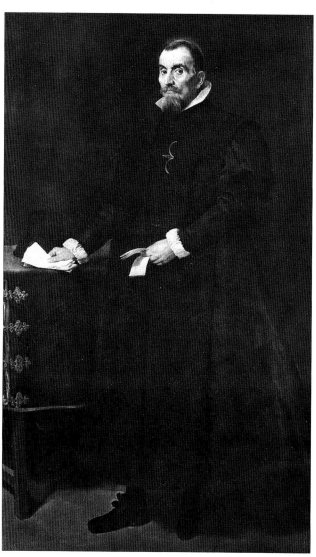

11. DON DIEGO DEL CORRAL Y ARELLANO. 1631–32. Oil on canvas, 84 5/8 × 43 3/8″. *Museo del Prado, Madrid*

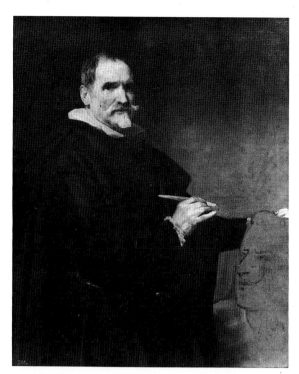

12. THE SCULPTOR JUAN MARTÍNEZ MONTAÑÉS AT WORK. 1635–36. Oil on canvas, 42 7/8 × 34 1/4″. *Museo del Prado, Madrid*

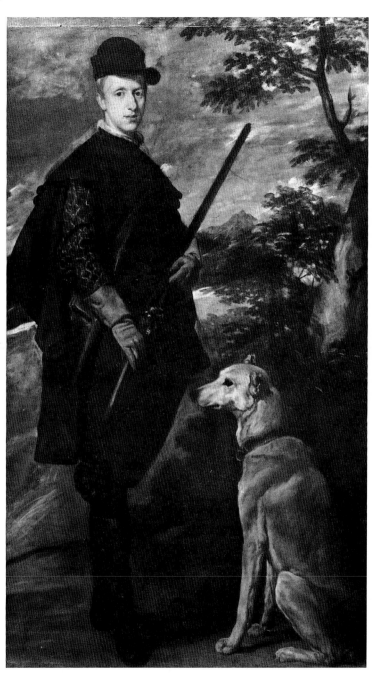

14. THE CARDINAL INFANTE DON FERNANDO AS A HUNTER. c. 1632–33. Oil on canvas, 75 1/4 × 41″. *Museo del Prado, Madrid*

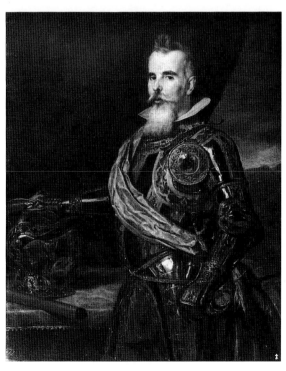

13. THE COUNT OF BENAVENTE. 1648. Oil on canvas, 42 7/8 × 34 5/8″. *Museo del Prado, Madrid*

one: how to convey the feeling that what we see is a living person caught in a crucial pose that is not only the height of believability but, at the same time, also the most decidedly straightforward in terms of lifelikeness and pictorial honesty. How can we know for sure whether or not the painter is faithfully communicating the model's personality or a persona the model has assumed? At least in the important portraits, Velázquez's subjective alteration of the model is very slight, as is his tendency to reduce individuals to figural types. In all cases, when an artist resorts to psychology, an initial glance evolves into a veritable "report," and always necessitates the analysis of outward appearances, of the visible details of the real world.

Now, even if we disregard those adjustments made during this process due to purely pictorial considerations—and whatever the importance of moral considerations may be—it can be said that for Velázquez the importance of personal feelings vis-à-vis the person depicted bears not the slightest resemblance to certain qualities in the work of an artist like Goya—apparent to his contemporaries and to posterity alike—who painted portraits out of love and hate in addition to cold official effigies.

The word "objectivity" always gives us pause. But as for Velázquez's psychological realism, a distance was established and preserved that rejected emotional struggle with the model and any opportunities for explicit communion. At the end

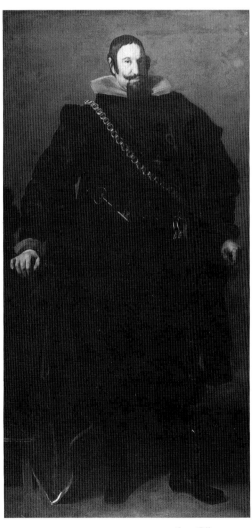

15. THE COUNT-DUKE OF OLIVARES. C. 1624. Oil on canvas, 80 × 41 3/4". *Museu de Arte de São Paulo*

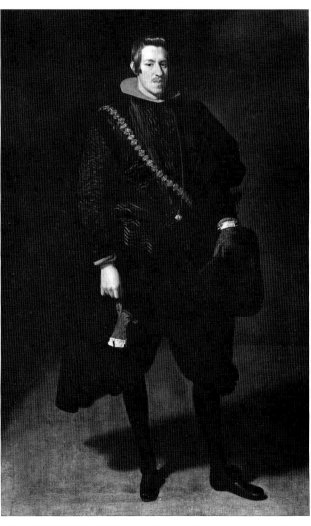

16. THE INFANTE DON CARLOS. 1625–27. Oil on canvas, 82 1/4 × 49 1/4". *Museo del Prado, Madrid*

of the creative process, the differences between individuals counterbalance the indifference that would result from too apparent a domination on the part of the artist. Maintaining these differences is the painter's first task; they have the added advantage of guaranteeing against stylistic inhibitions in the execution of commissioned portraits.

Technically speaking, Realism is an art of illusion, nothing more than a theater set where lighting and staging are geared toward verisimilitude, toward achieving a "realistic" effect. Turning now to the development of Velázquez's pictorial technique, the object to be copied was perceived and rendered in such a way that we have a sensation of the material of which the object was made—a unique accomplishment indeed. Realistic lighting was the touchstone of this style, which not only avoided trompe l'oeil and the systematic use of chiaroscuro, but also toned down dramatic effect and any invitation to reverie. Even the artist's contemporaries recognized his innovative tendency to express by means of vigorous brushwork the sensation of luminous reflections, vibrant and multicolored. As early as 1620, the writer Francisco de Quevedo y Villegas noted the interest in optical devices and technical processes used to depict the world ". . . with his [Velázquez's] separate spots of color that represent truth itself, not simply a likeness." In 1627, García de Salzedo Coronel hailed Velázquez as "a skillful painter whose glorious art rivals Nature and leaves her dumbfounded." Velázquez's artistic development conformed to the discipline imposed by his will to be economical in the expenditure of time and energy, inquisitive about life's diverse experiences, and proudly determined not to follow a prescribed aesthetic path.

In spite of Pacheco's preference for the great classical artists of Italy, the young Velázquez, as an apprentice, devoted himself at first to that form of Caravaggism then held in esteem among Sevillian painters. Pacheco gave his favorite pupil the freedom to go his own way, surmising that the young man possessed qualities that, under the master's solid cultural guidance, would divert him from complacently following artistic fashion. From the moment he entered court in 1623, the precociousness of his stylistic individuality ex-

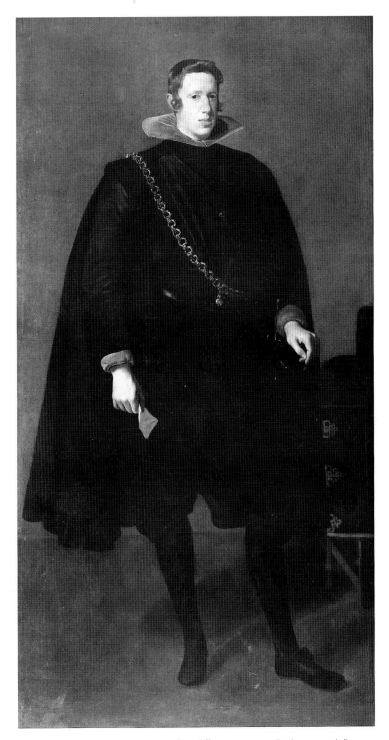

17. PHILIP IV, KING OF SPAIN. 1624. Oil on canvas, 78 3/4 × 40 1/2". *The Metropolitan Museum of Art, New York. Bequest of Benjamin Altman, 1913*

ceeded the king's expectations. This painting style was marked by strong contrasts of light and bold impasto that required one to step back in order to read the whole image, but often enough the artist avoided the theories of modeling that characterized strict Caravaggism. After 1618–20, these experiments in "luminism" followed a path alien to any existing school. Spain was in the process of adapting Tenebrism to its own needs. Granted, like most European painters at the time, Velázquez did not follow El Greco's example, and continued to use dark tones. Even so, the extremely adept way he manipulated lighting paved the way for the multiplication of light sources in the future. This facility in handling light operated within the boundaries of figurative verisimilitude, directing the viewer's attention toward selected details by playing on mirrors and lighted spaces. To the honesty and the tricks and technical traps necessary for a realistic effect the artist added the imperious need for style; to a concern for natural lighting were added an astounding subtlety and virtuosity.

Meeting Rubens in 1628 helped convince the young painter that, as he doubtless had already suspected, every great artist must temper his personal tastes with a discipline all the more rigorous if he wishes to be independent. At Rubens's prodding, Velázquez made his first trip to Italy in 1629–30. While in Italy, Velázquez became aware of how much more important the role of light was in the paintings of the Venetian masters Tintoretto and, especially, Titian, than it was to the overplayed greatness of Raphael's style or the recourse to dramatic realism that characterized the work of Caravaggio. Upon his return, Velázquez's canvases brightened and became more accomplished: his flat tints now glistened with droplets of color and his rapid brushstrokes made every corner of a painting vibrate. The second voyage to Italy (1650–51), undertaken at a more mature age, was to free him completely from Tenebrism. The spectrum of his palette grew lighter still, and the highly praised coloristic "touch" and the luminous atmosphere that pervaded the entire

18. Tintoretto. JOSEPH AND POTIPHAR'S WIFE. c. 1550. Oil on canvas, 21 1/4 × 46 1/8". *Museo del Prado, Madrid*

19. Tintoretto. SUSANNA AND THE ELDERS. Early 1550s. Oil on canvas, 22 7/8 × 45 5/8". *Museo del Prado, Madrid*

20. Paolo Veronese. VENUS AND ADONIS. c. 1580. Oil on canvas, 83 1/2 × 75 1/4". *Museo del Prado, Madrid*

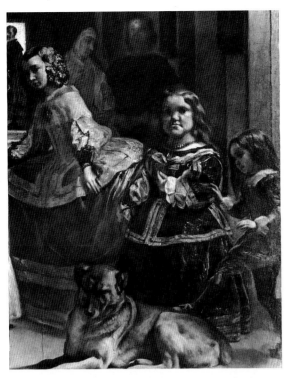

21. DOÑA ISABEL DE VELASCO, THE DWARFS MARIBÁRBOLA
AND NICOLASITO PERTUSATO, AND THE DOG, detail
of THE MAIDS OF HONOR

22. Pierre Auguste Renoir. MADAME CHARPENTIER AND HER
CHILDREN, detail. 1878. Oil on canvas (complete work
60 1/2 × 74 7/8"). *The Metropolitan Museum of Art,
New York. Wolfe Fund, 1907*

canvas first appeared. These effects of light and color imparted a depth and a lifelike dimension to figures and objects, in turn near and far away, sometimes presupposing a system of variable focal points within a single painting. Realizing that a picture took on a life of its own without violating the principles of Realism, two centuries later Manet and Renoir would apply this approach to their own pictorial conceptions.

Exceptional ability—not to mention exceptional self-confidence—was required to ensure the success of a painting style intended to be both convincing and visually appealing. Velázquez's powers of perception seem to have developed, uninterrupted, becoming more and more ambitious, and his art, in turn, became increasingly capable of expressing them; his painting grew "richer," so to speak. Had he not met Rubens (whose style, however, was quite different from his own) nor traveled to Italy, it is doubtful that his development would have been the same. In any case, it is surprising that, after his appointment as

Palace marshal, he found any time to paint at all. Some feel that when he did find time, he painted very rapidly and neglected to rework these fortunately "unfinished" canvases; others picture him frustrated by his inability to give his work as much care as he would have wished. In all probability, after a certain time he painted only what pleased him. He was allowed to complete commissioned works at his own pace, through the good graces of the king, who was understanding and allowed himself the luxury of indulging an exceptional artist of whom he was extremely fond. It is even more surprising still that when Velázquez set to work on a large canvas, he made no drawings and appears to have eschewed studies and preliminary sketches. Combining a firm belief in the primary importance of color with the undisputed ability to work directly with the brush, Velázquez fashioned a truly astonishing technique. And yet, despite the success of certain of his assistants and disciples, his style of painting did not give rise to a school of followers. It did, however, presage Im-

19

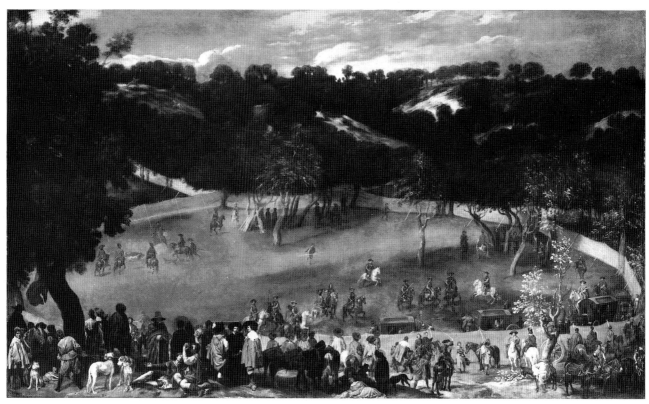

23. Velázquez (and assistants?). THE ROYAL BOAR-HUNT. Before 1643. Oil on canvas, 5′ 11 5/8″ × 9′ 10 7/8″. *National Gallery, London*

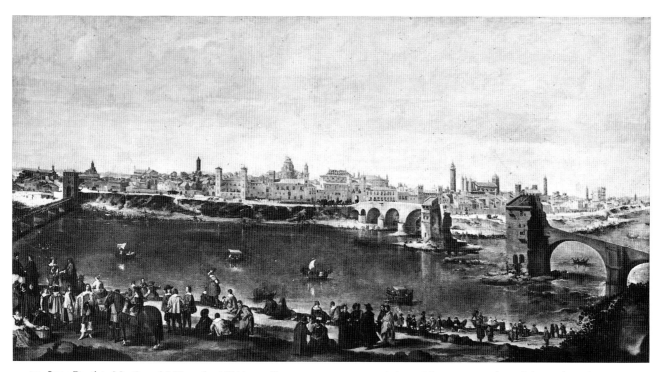

24. Juan Bautista Martínez del Mazo (and Velázquez?). VIEW OF SARAGOSSA. 1646–47. Oil on canvas, 5′ 11 1/4″ × 10′ 10 3/8″. *Museo del Prado, Madrid*

pressionism in its lengthening of brushstrokes; the role of visual sensation; the carefully applied layers of color; the manner in which the hard-edged volumes of the earlier works gave way to a dissolution of forms; the importance given lighter colors and atmospheric light. True, he was not an outdoor painter, and he never totally eliminated black from his palette. But his skill in accenting with a silvery transparency the gray and pink color harmonies in his works was unequaled, and served to heighten the mirrored reflections, as well as—on a purely pictorial level—the reflections of the objects themselves. This technique of suggestion in serious painting undoubtedly stemmed from an artisan's love of his craft. Of course, Velázquez's contemporaries did not evaluate pictorial art as we do today. But they did acknowledge that Velázquez—who, incidentally, was charged with purchasing great Venetian paintings for the king—like a good many other painters of genius of his time, went from a dense treatment of highly colored objects to a broad, airy style. The one dynamic element in this otherwise extremely static manner of painting is the soft, diffuse light that gives it its rhythm, balances the composition, and, in the end, dominates it completely.

At the risk of sounding tedious, a brief examination of Velázquez's place with regard to the

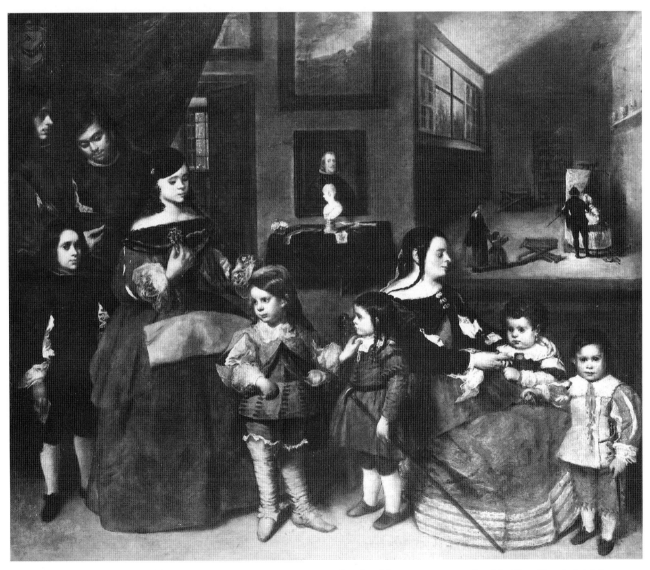

25. Juan Bautista Martínez del Mazo. THE FAMILY OF THE ARTIST. c. 1659–60. Oil on canvas, 59 × 67 3/4″. *Kunsthistorisches Museum, Vienna*

themes and to the aesthetic choices and techniques espoused by the leading Spanish artists of his day will shed considerable light on the specifics of his masterful style. Velázquez was still quite young at the time of El Greco's death: the Toledo master's direct influence was no more accessible to him than to any of his peers. Still, certain of Velázquez's stylistic concerns, though out of keeping with accepted techniques at the time, did bear some resemblance to El Greco's: for example, a particular way of applying color in vivid patches. This need to capture light and translate it onto canvas by means of the often fragmented strokes of a loaded brush leads to the more all-encompassing problem of how to utilize to best advantage those new aspects of the craft and the pictorial material that could not be overshadowed.

Similarities and differences . . . Clearly a contemporary of Velázquez, Jusepe de Ribera worked chiefly in Valencia, and his proximity to the port of Naples placed him in close contact with Italian painting of the Caravaggesque school. Ribera's painting style was characterized by a strong use of chiaroscuro, with the dark tones predominating. By overdoing his technique to the point of exaggeration, he created spatial areas so compact that the result was a kind of expressionistic setting that went far beyond dramatic realism. Whether due to cause or effect, treatment of the human figure differed markedly in the work of the two painters. Basing the characters in his poignant, or sometimes violent, religious scenes on popular types, and using models often chosen from among the common people, Ribera emphasized their coarse outward appearance as a ubiquitous trait that he eventually restrained and stylized. But Velázquez, on the other hand, retained a certain open quality in his figures; even the joviality or seriousness of the bumpkins is preserved. When he concentrated on specific figural types, he endowed them with the zest, humor, and the expressive mischievousness of the picaresque hero. Although he usually did not portray violent or wicked types, one can't help but imagine that he would have treated even the most extreme vulgarity with the same relentless objectivity. The aesthetic dilemma cannot be summed up as merely the exact duplication of appearances or their exaggeration

for the sake of higher truths—such as the illustration of Christian themes. Ribera clearly accentuated the wrinkles and the emaciated look of those of his models whose flaccid skin was an indelible mark of old age. But Velázquez looked beyond the morbid for that characteristic that would truly evoke a personality, and, in this sense, he is by far the more objective artist of the two.

Turning toward Andalusia—with Seville as the hub of its artistic activity—we find Francisco de Zurbarán, Bartolomé Esteban Murillo, and Juan de Valdés-Leal. In terms of our previous reflections upon truth (to which we shall be returning), the art of Zurbarán most closely resembles that of Velázquez. Zurbarán analyzed his models with the most extreme rigor, and when he transposed them onto the canvas, despite his alterations, they retained something of their undisguised ordinariness. However, the profundity of human experience is touched upon especially in the contemplation of his scenes of monastic life; in these works the artist aimed for the sublime, through a contemplative and sometimes visionary mysticism that had little appeal for Velázquez. Significant differences in technique stand out as well. Zurbarán worked with sculptural and geometric planes, without violent contrasts, but he still failed to add detail to his flat style and flat tints. If he does have anything in common with Velázquez, it is his care in the selection of color and value harmonies, and his unified color scheme, an effect that in music would be called "variations on a theme."

The difference between Velázquez and Murillo is even more apparent and aesthetically significant. It underscores how much the former stood apart from traditional Spanish art when he added his own personal touch to religious subjects. Whether or not he was uncomfortable in this domain, Velázquez's approach to this kind of painting was marked by a cautious accuracy. But Murillo—despite the presence in his work of certain ordinary, domestic elements, as in *The Miracle of San Diego* (or *The Angels' Kitchen*)—specialized in a kind of popular religiosity, such as was advocated by the Jesuits, tinged with a strain of superstition, which was ideally suited to that ostentatious religious fervor all too familiar to the Spanish people. Velázquez may have sensed something deceptive

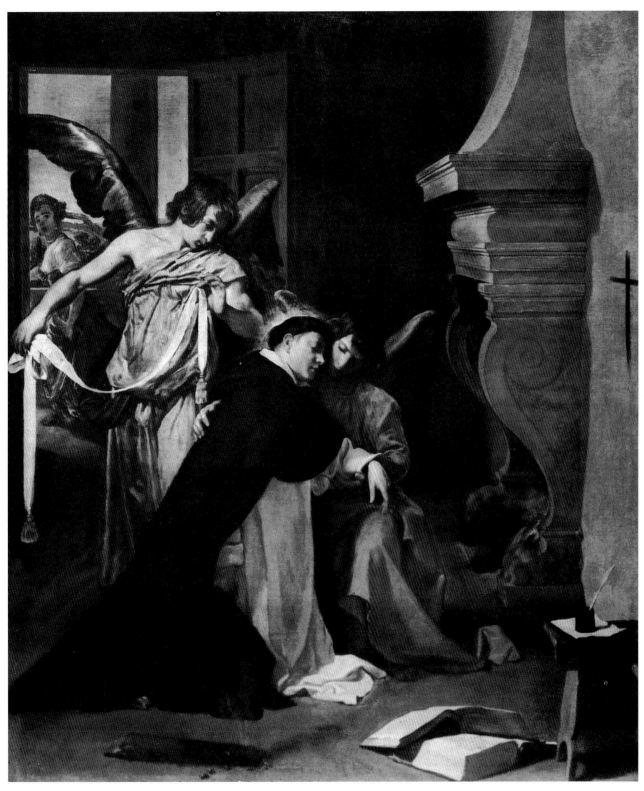

26. THE TEMPTATION OF SAINT THOMAS AQUINAS. 1626–28. Oil on canvas, 96 1/8 × 80″. *Museo de la Santa Iglesia Catedral, Orihuela (Alicante), Spain*

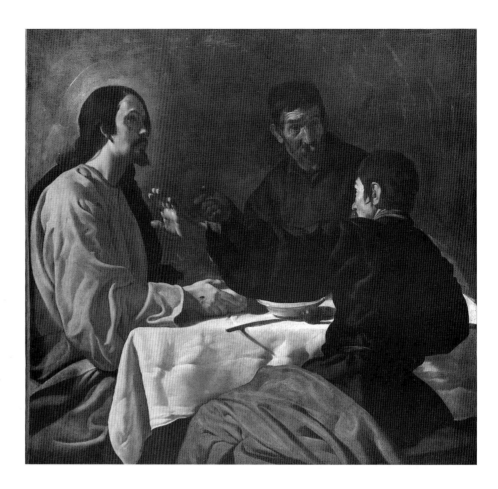

27. CHRIST AT EMMAUS. 1628–29. Oil on canvas, 48 1/2 × 52 1/4". *The Metropolitan Museum of Art, New York. Bequest of Benjamin Altman, 1913*

about this kind of faith; or he may have simply mistrusted any form of exaltation that prevented the artist from rendering an unclouded account of the times, and a truthful commentary on man and the dignity of his intellectual and artistic achievements. Whatever the reason, Velázquez turned away from this approach as well. His religious works, at their most evocative, are closer in spirit to those of a sculptor such as Juan Martínez Montañés. For instance, Velázquez avoided such difficult, mystical, and spectacular subjects as episodes from the lives of the saints. Murillo's mystical sensualism, Ribera's naturalistic impulses, Zurbarán's internalized fervor—all were alien to the very spirit of Velázquez's art.

But the comparison between the work of Velázquez and Murillo should also take into account Murillo's portrayal of his models as popular types in other paintings besides his religious compositions, especially his urchins of Seville—vagabonds that recall the picaresque novel *La Vida de Lazarillo de Tormes*—in which he stresses the pic-

turesque details of their coarse appearance and loose morals, when Velázquez would still seek out their dignity. It hardly comes as a surprise to see Murillo, as well, emphasize chiaroscuro effects and subjugate his color scheme to serve the aesthetic imperatives of drama and the picturesque. However, the tricks of arranging and distributing color in order to effectively render reality and create a plastic universe on the canvas, and the methods of employing such contrasts, Murillo shares with Velázquez.

Finally, the pictorial dynamism of Valdés-Leal's oeuvre—his allegories of vanity and death, whose symbols and motifs were drawn from medieval sources—remains diametrically opposed to the sobriety of the art of Velázquez, which scarcely, if ever, displayed such symbolism. This leads us to the question of the ability of a certain order, a specific kind of truth, to ultimately triumph over myth.

Triumph over myth! If we at least bear in mind that myths are only stories, used by people to explain and understand the situations in their lives,

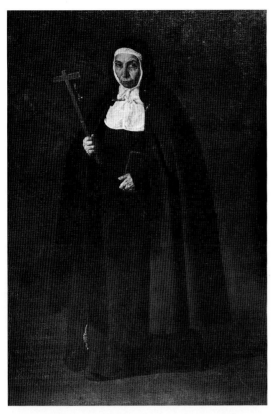

28. MOTHER DOÑA JERÓNIMA DE LA FUENTE. 1620. Oil on canvas, 63 × 43 1/4". *Museo del Prado, Madrid*

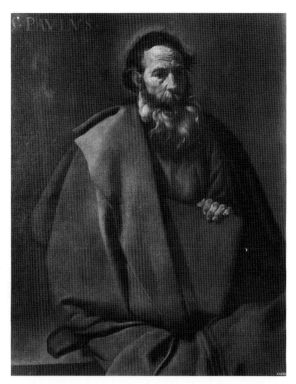

29. SAINT PAUL. c. 1619–20. Oil on canvas, 35 5/8 × 30 3/4". *Museo de Bellas Artes de Cataluña, Barcelona*

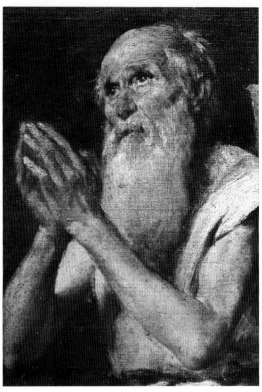

30. SAINT PAUL, detail of SAINT ANTHONY ABBOT AND SAINT PAUL THE HERMIT. c. 1634–60. Oil on canvas (complete work 8' 5 7/8" × 6' 2"). *Museo del Prado, Madrid*

the risk of regarding them too highly is minimized. For myths may appear flowery at the outset, but, under the pretext of tradition, they tend to become empty and sterile as subjects. Do not allow metaphor to become an end in itself. Without claiming to be a destroyer of beliefs, Velázquez could still be considered a powerful destroyer of fictions. Yet one must recognize what in fiction is an aesthetic touch, a quotation, or a fashionable prop. The artist who is eager to make his paintings reflect a human outlook and human perspective—even if he is not at all tempted by fictional literary works— may still enrich his portrayal of reality with fictive elements. He may even portray reality as everyday experience, but by not developing the mysteries of a fourth dimension in his imagery he renders a twofold service to mankind.

Let us discuss more fully the disparities between the elements of various works that we touched upon previously. The process of reduction so apparent in *The Forge of Vulcan*—in which the splendid mythological figure of Apollo accentuates

the human qualities of the blacksmiths—obtains in two other works as well. In *Los Borrachos* (or *The Drinkers*; colorplates 10, 11), the god, who resembles the surrounding figures, is a much more believable deity, while in *The Toilet of Venus* (known as *The Rockby Venus;* colorplate 33), we see a marvelously sensual female nude—a rarity in Spanish painting of the period—without the usual characteristics that traditionally were associated with images of the goddess. Even though this is not a case of calling the Christian faith into question, details from the physical world, when incorporated into the supernatural world of Christianity, endow these religious themes with touches of reality which are totally natural. When united in this manner, the sacred elevates the ordinary. As an example, let us now reconsider *Christ in the House of Martha and Mary*. The Biblical episode—which is the painting's principal subject—is enframed and lit in such a way that the brilliance of the painting-within-a-painting not only transforms the modesty of the domestic scene, but, to our surprise, we can detect a definite correspondence to both the open space of supernatural subjects in Italian art and the treatment of space in paintings of Dutch interiors.

The ingeniousness and complexity of such paintings as *Las Meninas* and *The Spinners* (or *The Fable of Arachne*) are governed by strange rules that go beyond the requirements of illusion and elude logic itself, but one must still not dismiss them as mere flights of fancy. If anything, they underscore the coexistence—perhaps hierarchical—of the diverse conditions and occupations of people from different walks of life. It is as if the system of correspondences and parallels in *The Spinners* enabled the subject of the tapestry to control the motif of the "real" scene, namely, the attitudes of the Spanish women at work. The painting also displays the artist's effective use of fable to comment more eloquently on the era he wishes to depict.

Surely thematic richness and all that it implies are somewhat related to the unlimited possibilities of plastic and pictorial richness. And yet, the fact remains that the latter kind of richness is just as obvious in the portraits, whose subjects are apparently a good deal less intricate. Among these, of course, one must include the unconventional

"portraits" of mythological deities: *The Toilet of Venus, Mars*, and even *Mercury and Argus* (colorplate 39), which was painted at the same time as the last portraits of the Infantes and Infantas. Whether or not their titles conceal historical references or analogies, they take their place among the other representations of highly individualized models, examined at close scrutiny.

These triumphs and renunciations define a special strain of classicism, first and foremost free of the restrictive principles of traditionally accepted aesthetic codes. Velázquez seldom copied models from antiquity and scarcely became an authority on historical accuracy. What he inherited from the Venetians—whose art was stylistically so free—he thoroughly integrated into his own art. This should not be interpreted as a thinly disguised, opportune form of stealing (apparent only to "cultured" minds) from well-informed sources. In fact, outside references are either openly adapted, or else called attention to, and those borrowed elements are set off with irony (Apollo in *The Forge of Vulcan*) or a show of deference (the Rubens in *Las Meninas*). Such an open style of painting usually can effectively dispense with indirect allusion and an inapplicable artistic code, if not with the sometimes obligatory adherence to tradition.

In this respect, Velázquez stands apart not only from the mediocre artists of his day, but also from the voluntarist and occasionally rhetorical tendencies of a renowned classical painter such as Nicolas Poussin (whom he may have met while in Italy). Moreover, despite Poussin's sense of balance and composition, he sometimes gave in to a highly intellectualized pathos and a grandiloquence of gestures and poses still, however, nowhere near Caravaggio's dramatic effects or the dynamism of Gian Lorenzo Bernini's style. This was undoubtedly due to the exacerbation of certain aspects of traditional aesthetics by the Baroque style, after the death of Michelangelo. All the more reason why Velázquez, unimpressed as he was by theatricality, did not succumb to any of the great temptations of Baroque art. Nor did he yield to those artifices of appearance that extinguish life with speed, flightiness, dreams, or subjectivity. Or to those two opposing excesses, naturalism and preciosity. He was capable of a discreet sense of

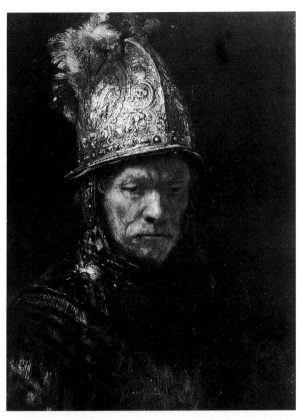

31. Rembrandt. MAN IN THE GOLDEN HELMET. c. 1650. Oil on canvas, 26 3/8 × 19 3/4″. *Staatliche Gemäldegalerie, Berlin-Dahlem*

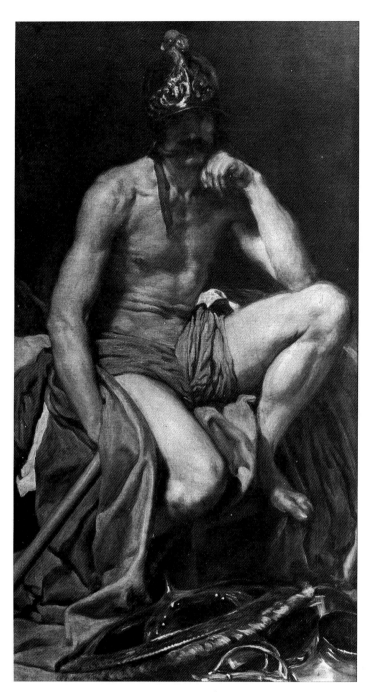

32. MARS. c. 1639–42. Oil on canvas, 70 1/2 × 37 3/8″. *Museo del Prado, Madrid*

humor that, if need be, could put plastic and mythological allusions in mock-heroic perspective, without bordering on the burlesque. At the same time, Velázquez avoided any Mannerist affectation and elongation of form. One may regret his judicious disdain for lyricism and the various forms of expressionism. But precisely because his aim was neither to adulate nor to ridicule, even Apollo, though unearthly, is the bearer of a "true" light.

Rubens—humanist, diplomat, world traveler, and painter, who was granted the favor of princes, and a still greater wealth and reputation—had, uncontestably, a temperament of much more complexity. He studied the ancients in order to recapture their heroic spirit; was an admirer of Titian for the Venetian master's freedom of touch and the brilliance of his colors; and also appreciated the contrasts and emotional intensity of Tintoretto and Caravaggio. The Flemish artist demonstrated a Baroque taste for flesh and for fire that, at its most convincing, could blend together unresolved associations or dualities—the profane and the divine,

27

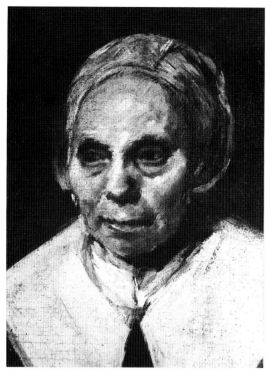

33. Frans Hals. OLD WOMAN, detail of WOMEN GOVERNORS OF THE OLD MEN'S ALMSHOUSE, HAARLEM. 1664. Oil on canvas (complete work 67 1/8 × 98 1/8"). *Frans Halsmuseum, Haarlem, The Netherlands*

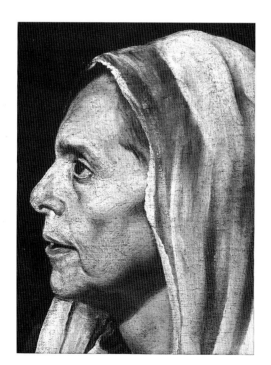

34. OLD WOMAN, detail of OLD WOMAN COOKING EGGS. c. 1618. Oil on canvas (complete work 39 × 46"). *National Gallery of Scotland, Edinburgh*

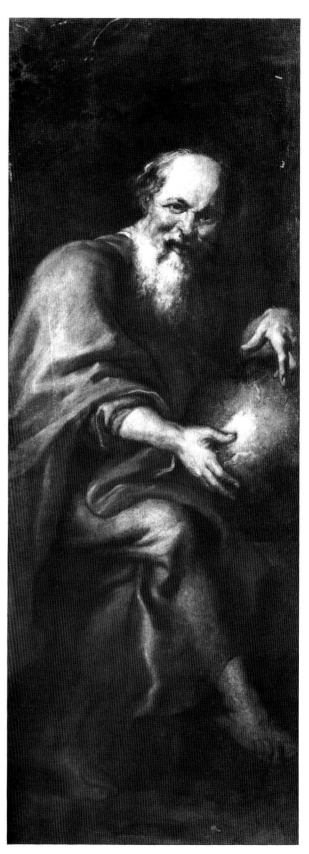

35. Peter Paul Rubens. DEMOCRITUS, or THE LAUGHING PHILOSOPHER. 1603. Oil on canvas, 70 1/2 × 26". *Museo del Prado, Madrid*

physical plenitude and the supernatural—in a hymn
to the body and to life, sometimes even bordering
on violent tragedy. His work surpasses Velázquez's
in vitality, but he does not avoid excess and pathos.
At its most decadent phase, the Baroque—an other-
wise rich and revolutionary movement, or trend—
eventually fell victim to two perils: superaestheti-
cism and hopeless ridicule. It was the vitality of
Rubens's style as well as Velázquez's positive form
of classicism that helped counter these two tenden-
cies.

The classicism of Velázquez is positive in that

his themes are depicted with the appropriate tone.
The outstanding quality of the classical writers and
artists of the seventeenth century was their develop-
ment of an ethic of respect for the model, the ob-
server, and the artist himself that was more worth-
while than a respect for order, power, and the
dictates of antiquity. Classical clarity, which one so
often connects with a subdued psychological real-
ism, blends the calm mastery of form with the
politeness of not dulling its argumentation or exag-
gerating the expression of its ideological and
aesthetic premises. It is marked by a will of experi-

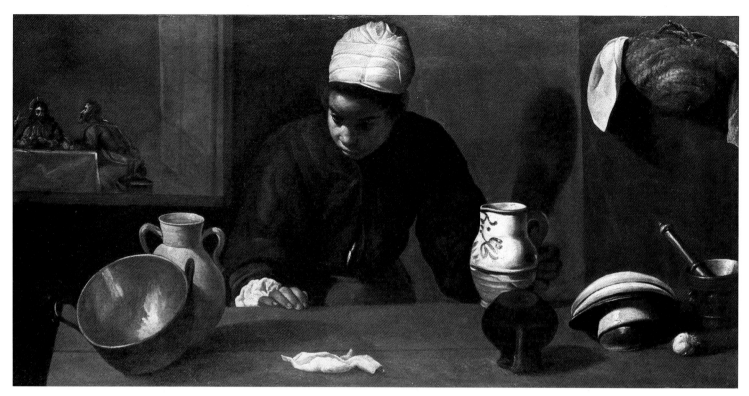

37. CHRIST AT EMMAUS. C. 1620. Oil on canvas, 22 × 46 1/2″. *Collection Sir Alfred Beit, Blessington, Ireland*

38. THE SERVANT. C. 1620. Oil on canvas, 21 5/8 × 39 1/2″. *The Art Institute of Chicago. Robert Alexander Waller Memorial Collection*

mental and critical rigor, in which knowledge—the enemy of vagueness, effusiveness, and bad taste—is capable of checking off and measuring the forces that underlie the visible and invisible, individual and societal aspects of mankind. Humanism lies behind this will to comprehend the natural order of things.

Without pettiness, Velázquez paints a closed world, and penetrates the individual personalities that comprise that society in all their varied aspects. This gentleman of the court, exposed though he was to court jealousies, was able to bring out the humanity of the drunkard, the servant, and the prince alike; even the obligatory stiffness of the royal portraits relaxed somewhat in works from the artist's maturity. Focusing, first, on the visible side of human reality, the artist gladly demonstrated its limitations as well as its beauty, so much so that whether health, happiness, and dignity are counterbalanced by disease and misery, melancholy idleness, or deformity, it is the equality of the soul that emerges above all, in the twofold sense of a stoic quietism (recall Velázquez's beggar-philosopher figures) and the basic equality of all men. Even if the joy Velázquez derived from painting was of a lofty and solitary nature, like that experienced by his fellow humanists Leonardo da Vinci and Rembrandt, the social responsibility and firm convictions of the classical artist led him to accord overriding importance to the figure. Velázquez balanced this interest in the human figure in relation to the customary violence of Spanish art. Whether presented straightforwardly, framed in a doorway bathed in light, or reflected in a mirror, the figure profited from the theme of the "windows" and from the best lighting from two light sources— natural light and that provided by art.

This is why Velázquez, turning his back on vulgarity, did not display more personal religious fervor or pander to that of others. Nor did he exploit the illusory grandeur of the myth to further his own interests. Moreover, his style can hardly be termed narrative, avoiding as it does dramatic action and movement. It is as if the painter cared first and foremost about the plight of human beings, or, better still, about human situations which are breaks in the smooth flow of life, whose progress is halted most often in an uneventful moment. Even

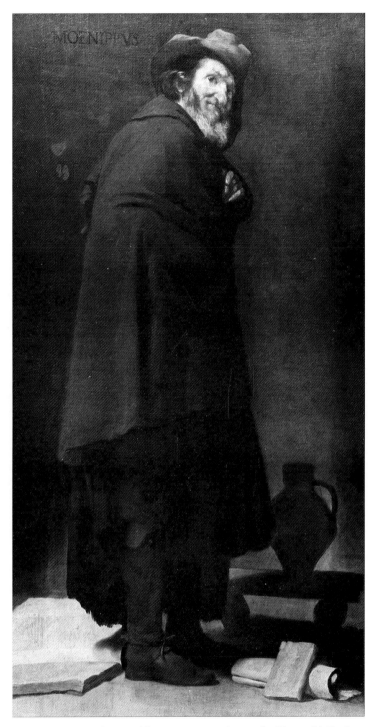

39. MENIPPUS. 1639–42. Oil on canvas, 70 1/2 × 37″. *Museo del Prado, Madrid*

the movement of gestures appears only rarely; there are few processions, little mechanical motion of human beings. An artistic vision like Velázquez's, though able to suggest the tension between the physical, intellectual, and spiritual sides of life, is incapable of rendering mystical experience and religious spectacle such as an artist like Murillo imagined were accessible to the saints. And those who have a feel for this mysticism are all too human.

What we are talking about, then, is presence, and its aesthetic manifestation. In the absence of the supernatural, the spectacular, or even the representation of action scenes, a type of moral life emerges. The poses ennoble the real and mortal countenances of the figures and, thus, of the models, and search out both the generalities and particulars beneath the carefully chosen elaborate stances. Velázquez refused to struggle with the inner life of man and his hallucinations as Goya would years later. Instead, his experienced eye objectified the traits of a personality to such a degree that it becomes a momentary—but forever exemplary—challenge to the universe. Even before

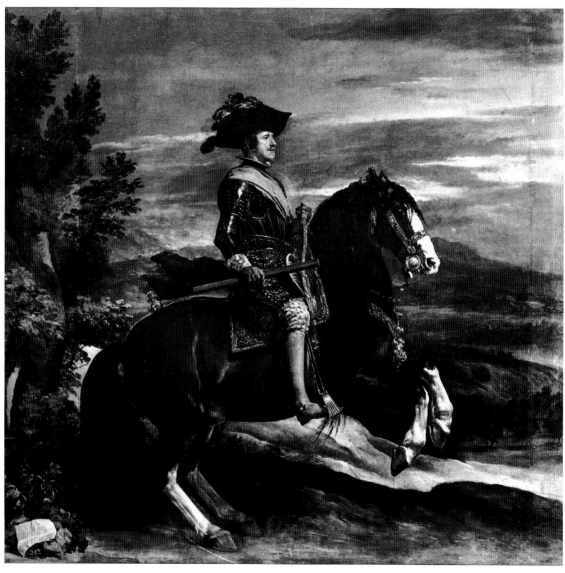

40. PHILIP IV ON HORSEBACK. C. 1634-35. Oil on canvas, 9′ 10 1/2″ × 10′ 3 5/8″. *Museo del Prado, Madrid*

considering whether the artist succeeds in making the figure part of a lasting pictorial harmony for posterity—man's? or art's?—we must point out, in justifying the need for immobility and suspended motion in the pose, that this manner of painting reveals the essence of human beings that lies beneath the surface and isolates them from the human drama in which they are caught. A painter can become a moralist and psychologist only if he works on the entire spectrum of living things.

Several additional characteristics may be ascribed to the openness of this form of classicism.

On the one hand, Velázquez does not totally reject compositions that slant upward—a feature sometimes considered specifically Baroque—as evidenced by such religious paintings as *The Virgin Presenting the Chasuble to Saint Ildephonsus* (colorplate 8), and equestrian portraits such as that of the Count-Duke of Olivares (colorplate 21). (In other works, such arrangements are combined with frontality and horizontal balance.) On the other hand, in representations of a calmer way of life, objects occupy a place—such as one will re-encounter later in the work of Jean-Baptiste-Siméon

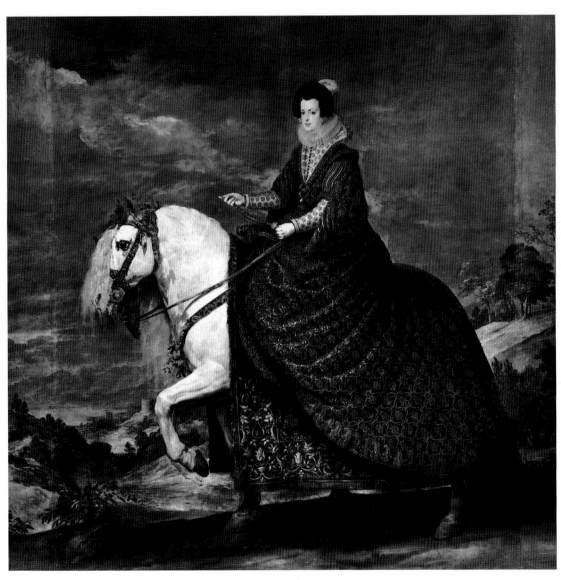

41. QUEEN ISABELLA OF BOURBON ON HORSEBACK. C. 1628-35. Oil on canvas, 9′ 10 1/2″ × 10′ 3 5/8″. *Museo del Prado, Madrid*

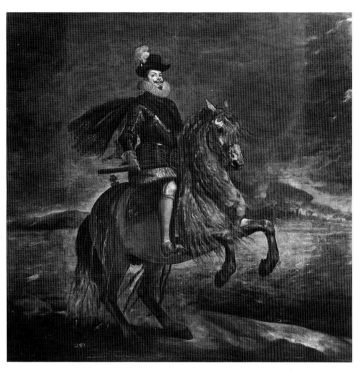

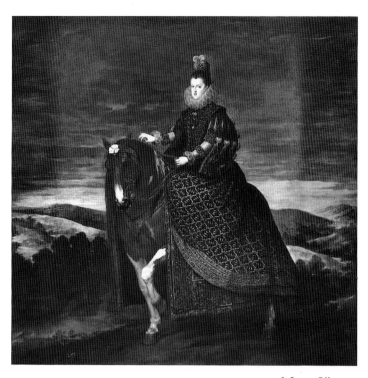

42. PHILIP III ON HORSEBACK. C. 1628–35. Oil on canvas, 9′ 10 1/8″ × × 10′ 3 5/8″. *Museo del Prado, Madrid*

43. QUEEN MARGARITA OF AUSTRIA ON HORSEBACK. C. 1628–35. Oil on canvas, 9′ 9″ × 10′ 1 5/8″. *Museo del Prado, Madrid*

Chardin or Cézanne—that neither corresponds to the genres practiced by the minor masters of the North, nor to the psychological realism of the classical writers. By that we do not only mean the props that define an individual with regard to his official duties or his personal tastes, or those that create mythological or religious settings, or the costumes that allow us to recognize a figure as Mars or Bacchus. In the *bodegones* and in certain portraits there is a good deal more: a love for the things that surround man, and especially for those objects fashioned by his own hands, which even comes before the strictly pictorial results (to be examined later), of his dialogue with the visible world. Here is a classicism that has become an actuality, lively and up-to-date. The intimate reality that this classicism focuses upon and then interprets is comprised of valuable truths which are its ultimate objective and highest aim.

Beneath, but not beyond the surface of reality lies its primary and perhaps its only decipherable mystery: nature and her laws. A concern for truth, which leads one to attempt to comprehend, utilize, and convey these laws, must perceive them initially with a style that seeks the structures governing the visible world which lie beneath our sense-impressions. These discoveries enliven the resulting aesthetic expression, sometimes drawing upon myths in the process. The stronger the feeling that the world has an analyzable structure, the greater the distance between sensation and expression. (In other words, the retransmission of sensation requires a greater reflection upon truth.) Thus the name Impressionists is misleading, and one would be wrong in believing that the immediacy of their interpretations of what they felt spared them from any analysis of reality, matter, forms, and colors. Cubism would go even farther in its attempts to restructure reality. However, prior to this movement, many great painters devoted themselves to a similar goal, among them Velázquez, for whom the world was anything but a dream.

"*Al pintor de la verdad*" ("the painter of truth") reads the inscription on the pedestal of the statue of Velázquez in Seville. The universal glory that accompanies this title must not be taken lightly. The painter whose works are so deeply rooted within his own era methodically studied the depen-

dence of human beings and things on general laws. Illusion itself stems from science: for example, in *Joseph's Bloody Coat Brought to Jacob* (colorplate 12)—one of the rare "theatrical" paintings that Velázquez left to us—the time-honored lessons of perspective, the treatment of the drapery, and the composition are impeccably combined. And the court painter, now so free with his audacity, even when he boldly presents his models with a certain blurring of outline and a softening of contours in order to suggest the atmosphere and the mood that surrounds them, does not deny the balance underlying their structure, thereby making light compatible with the solidity of the human forms. A truly

44. The monument to Velázquez in Seville

intelligent representation of reality is neither the thing itself nor a photographic copy. This careful work, in which even gestures of exhilaration are suspended in time, does not seize upon an image from life and then merely let events resume their course as before, but does so in order to retain from the image whatever qualities it possesses that are both fleeting and lasting. The painter thus shows us that life can perhaps be depicted on canvas with the dual purpose of self-recognition and self-knowledge, and that art is an act of mediation that strips away the masks. By playing with mirrors, one does not necessarily end up with the illusion of illusion, or with "pure" beauty—nor with the destruction of reality, for its spectacular impact is not mitigated by a double reflection. The transcending of appearance to capture light in the painting also captures the light of the real world in the process, and bestows the permanence of laws upon the historic body of men, as well as upon their ideological and objective universe. This phenomenon is what classicism—which unites truth and beauty—calls pleasing and instructing.

Such a fusion of intellect and vision therefore enables the observer to go beyond the mere witnessing of the events of his day in order to yield to the forces of natural laws, which include those of the mind. This concept reminds us of Cézanne's statement: "There are two things in painting, the eye and the brain: each must help the other. One must work toward their mutual development the way the painter does: by using the eye to observe nature and the brain to order the structured sensations that provide us with the means of expression."

The quest for truth in structured expression, especially in the area of psychological truth which we have already touched upon, increases accordingly if discretion is shown toward vitalism. Again, a comparison with Rubens serves as a case in point. Inspired, like Velázquez, by a wide range of subjects, the Flemish painter endowed every conceivable image with a whirling and tumultuously active life of its own, tinged with vital energy, and full of exuberance, fury, and splendor. Velázquez—though hardly a courtier here—gives us his assessment of the courtiers and buffoons, the children as well as the poets, but not without a feeling for their underlying tragedy that he would come to value

more fully later on. In theater, the authenticity that strips away the make-up of a comedic role corresponds in art to the portrait-as-object: by combining in-depth knowledge of the individual with care in executing a likeness, a secret is penetrated that is more in keeping with a rational discourse on Man—a discourse whose degree of generalization depends precisely on the incarnation of the subject, according to the well-known rules of the moralists. When confronted with these figures, and as a result of the scantiness of narrative detail, one has a feeling of permanence that topples the arbitrariness of accepted theories and academic rules, including such iconographical froth as the clichéd representations of this or that prince as hunter or horseman. By exactly measuring the imponderables of accident and contingency, the powers of the eye yield to the spirit of truth.

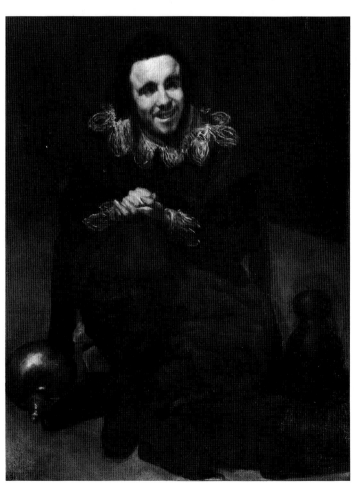

45. CALABAZAS. 1637–39. Oil on canvas, 41 3/4 × 32 3/4″. *Museo del Prado, Madrid*

Now, to arrive at truth presupposes thoughtful expression as well as style, but it also entails a process of truth by elimination. As we have already shown, this was classicism's kind way of simplification. Despite the diversity of Velázquez's paintings, and even certain cases of doubtful authenticity, they radiate a feeling of unpretentiousness and happy discovery. Full—sometimes even to the point of saturation—they hide the studied care and refinement and their underlying skill, and do not flaunt their technical expertise. To do so would make a fair chronicle of the times, the vividness of truth, and a discourse on mankind suffer in the process—so much so that an economical combination and constriction of resources in a work allow it to be defined, in a sense, as "less," in relation to the way in which other works demonstrate their perfection. Less than the harmoniously balanced compositions and the idealized rhythms and figures of Raphael. Less than the stylization, the arabesques, the refinements of composition and form of the Florentines. Less—although Velázquez owed much to them—than the Venetians' sensual delight in life, the decorative sumptuousness and the opulence of their forms and colors. Less than Caravaggio and the Bolognese school; less than the great contemporary masters of other European schools—Simon Vouet, Poussin, Rubens, Van Dyck, Hals, Rembrandt, and even Philippe de Champaigne.

Eighteenth-century Spain paid homage to Velázquez through the following words of Anton Raphael Mengs: "He painted truth not as it is, but as it appears to be." But we must bear in mind that he painted truth insofar as it can appear within the pre-established framework of what constitutes the reality of things, and that he determined its value among the signs of appreciation of reality that he found in his own era. Now, the selection and creation of truth—its reconstruction and restoration—enable us to classify imitations of nature better, according to the kinds of truth produced, rather than according to types of subject. We shall narrow these categories down to three. First, there is the method of chronicling history and mores—and let us remember that Velázquez did not pander to petty vanity nor did he employ the kind of political allegory that a painter like Rubens wielded

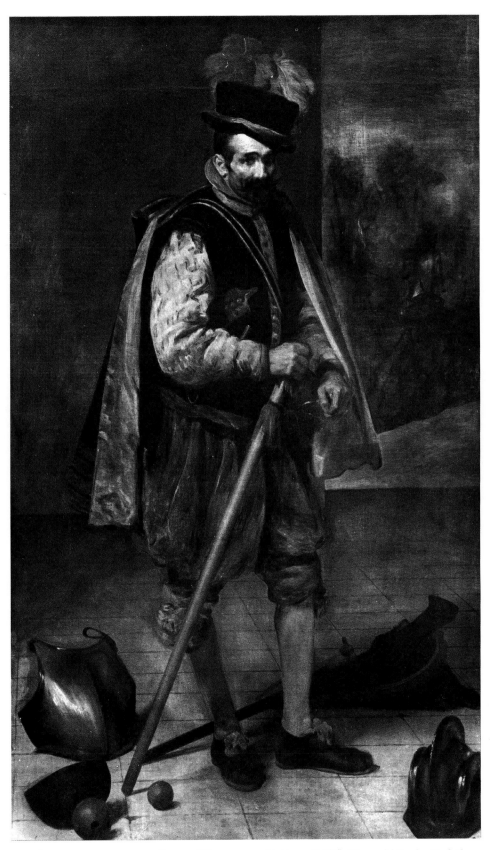

46. DON JUAN OF AUSTRIA. 1632–33. Oil on canvas, 82 3/4 × 48 3/8″. *Museo del Prado, Madrid*

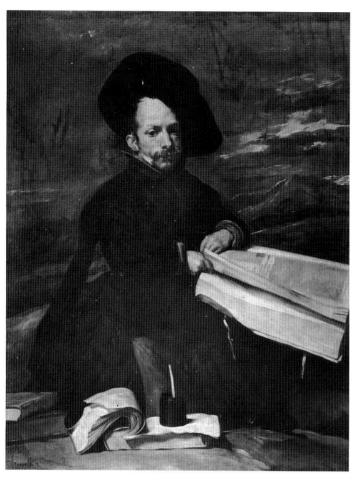

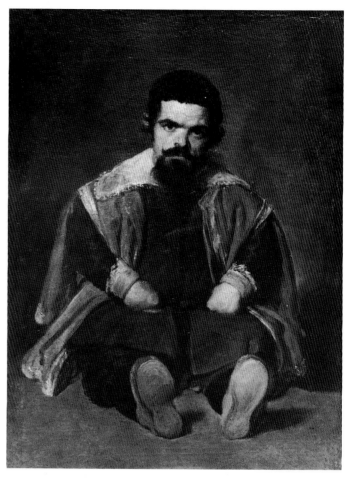

47. DON DIEGO DE ACEDO ("EL PRIMO"). 1644. Oil on canvas, 42 1/8 × × 32 1/4". *Museo del Prado, Madrid*

48. SEBASTIÁN DE MORRA. C. 1645. Oil on canvas, 41 3/4 × 31 7/8". *Museo del Prado, Madrid*

with such a masterly hand! Second, there is the method of utilizing the moral and psychological aspects of man as both the subject and object of reflection. Finally, there is the method of representing human endeavor, and the glorification of all work for which skill and sensitivity are required in order to reshape the world in the name of usefulness and beauty. This last category, by including painting itself, affirms the capacity of painting to be activity, product, and object. Apart from the fact that ferreting out truth in the world cannot be divorced from the acts of intelligence and representation, the artifices of painting are vindicated anew by the qualities it possesses of refined opulence and asceticism.

The theory of classicism, which occasionally pretends to see art merely as a means of expression,

is ill-suited to one additional dimension, namely, the unveiling of the supernatural—but also to aesthetic creation for its own sake. Does this imply a means of escape from the real world and its confirmed truths? Or a contradiction between art and the world? Let us now imagine a new superimposition: pictorial activity working with and upon the model in order to add to humanistic concern a love for painting. It is as if—and this is only an "as if" —the light that is transposed onto a canvas had a life of its own. In the case of Velázquez, the absence of storytelling; the crucial importance assigned to objects (not to be miscontrued, however, as an anti-humanist position); and the preference, finally, for painting situations that deprive historical events of their dynamism as well as their inaccuracies—help to tempt the artist to create

pictorial "objects," if not to explain himself through them. Out of an ordinary, tranquil universe there can arise another value, perhaps even a higher value than the valor of man, which in turn is acknowledged and demonstrated, a value which is that of painting itself. Painting opened the doors of posterity to Velázquez and enabled him to elevate mortal human beings to the level of art objects. The artist's perceptions and repertory of visual impressions gave rise to a visual poetry utterly free of distortion.

Rooted in this hypothesis and this process—regardless of what subjects are treated or what objects are chosen—is the notion of the picture as object, which becomes a factor of utmost concern, governing subsequent works by uniting their thematic and technical evolution. The relative abandonment of the *bodegones* and genre scenes in favor of commissioned portraits merely paved the way for the major compositions that followed. And while Spanish painting paid little heed to landscapes, Velázquez displayed the variety of his talents in his boldly painted views of the Villa Medici (colorplates 29, 30), executed while he was in Italy.

Palace life offers a painter more than just faces. It presents him with a sumptuous array of objects that have no more practical value than the tools of trade that Velázquez had already found so interesting. Indeed, they may have even less. But the decorative role of these objects is naturally enriched by the added pictorial dimension of their material and color. Its social function notwithstanding, the luxuriousness of a dress or a tapestry provides the best opportunity to suddenly leap from accurate interpretation to the enjoyment of beauty. In this sense also, the evolution of Velázquez's art would depend on his life as a courtier. If he so wishes, the observer can find in a painting, amid all its calm splendor, some elements of an emotional nature, perhaps even revenge for a hidden tragedy. But however satisfying it may be, a simple likeness inhibits our visual enjoyment. This ribbon or that splash of jewels are no longer merely theatrical accessories with which to adorn the human figure. Accuracy and the truthfulness of an image are not held to simply to satisfy curiosity, which bears out the feeling we sometimes have that the appearance of an object (the ribbon)

has been altered according to the place it will occupy in the overall composition. The execution of this ribbon is the temporary pictorial goal, though it is only a partial but necessary detail of a new spectacle to be enjoyed. The only thing "historical" about the resulting work is what it has borrowed from the history of forms and the history of visual and cultural enjoyment, and from nature, too, as a source of pleasure. But it is history nevertheless: remaining a recognizable image—that is to say, a motif with a reference to clothing in the real world, outside of the painting—the ribbon in the painting undergoes a metamorphosis of role as well as of substance.

Stated in simpler terms, the painter imposes an order that softens the harsh contrasts that exist between things, and within human existence—so ephemeral and at times so painfully ugly. He seeks this order in a light in which all that seems to remain, at close scrutiny, are zones of color. This leads us to several observations. Since a painting is composed anew by the glance of recognition on the part of the observer, it is not dependent on the ideal of escaping into the role of art-for-art's-sake. Love for beauty preserves the truth of a work and survives along with it. So the concept of "pure" painting would thus be erroneous if applied to this kind of painting—if, indeed, it can *ever* legitimately be used to describe a work of art.

Some people have occasionally used the notion of abstraction incorrectly, especially when categorizing abstraction and the art of Velázquez as "pure" art. They add that even the idea of painting as a superior illusion, which would result in the ideal or an art-for-art's-sake, would not undermine the human interest in Velázquez's paintings. It would be clearer to put it this way: just as tricks of lighting—light being an element of poetry and the veritable soul of the world—contribute to the overall truth of Velázquez's paintings and are less prone to inspire reverie than in Rembrandt's works, so, too, an Infanta makes us dream only because the pictorial vision includes the human dream of beauty as embodied by a little girl, without any need to speak of the ideal. In any case, how can we believe that aesthetics can be separated from a discussion of reality? Only if we assume that aesthetics reveals the lack of reality and then utilizes

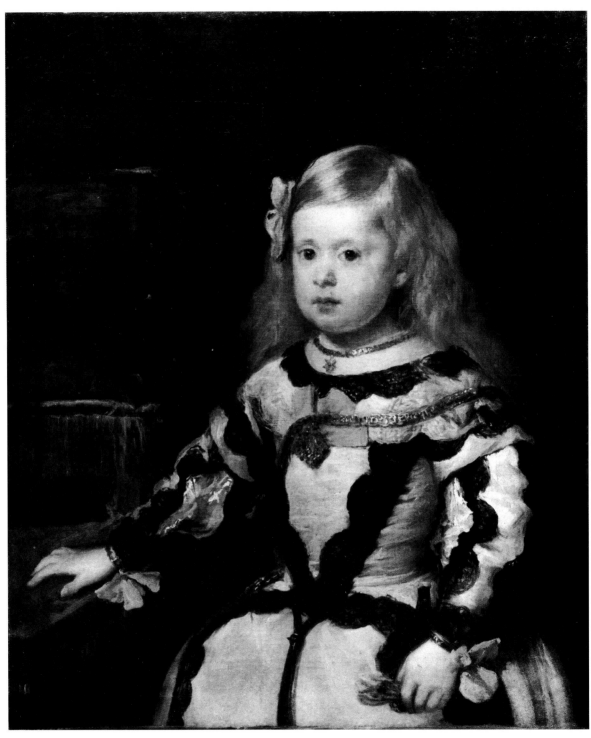

49. THE INFANTA MARGARITA. C. 1653–54. Oil on canvas, 27 1/2 × 23 1/4″. *Musée du Louvre, Paris*

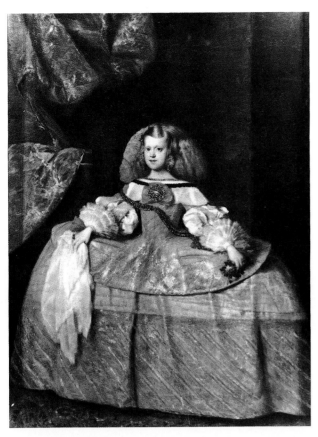

50. Juan Bautista Martínez del Mazo (?). THE INFANTA MAR-
GARITA. 1664-65. Oil on canvas, 80 3/4 × 57 7/8". *Museo
del Prado, Madrid*

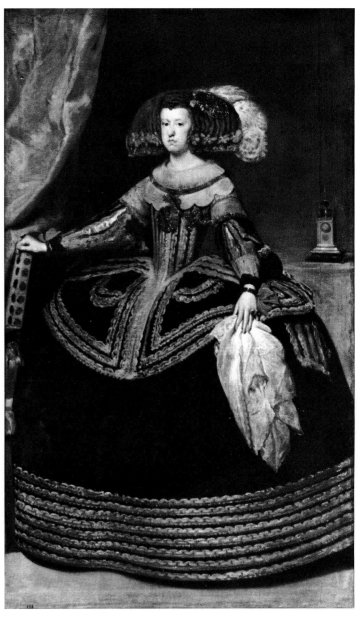

51. QUEEN MARIANA. 1652–53. Oil on canvas, 82 1/4 × 49 1/4". *Musée
du Louvre, Paris*

this absence upon which to base its very principles.
And how can we believe that a network of symbols
can be refined to the point of totally evading its
role as a medium of communication? If that were
to happen there would be nothing more to say, the
discourse would then become purely an object of
enjoyment, either very serious or very exalted. . . .
Objects of this sort age quickly.

As we try to superimpose, one upon the other,
and to reconcile all the virtues of Velázquez's
artistic vision, what emerges is neither an embel-
lishment of nor a withdrawal from the world. What
we do end up with is, at most, a sensitivity that
completes the overall meaning being communi-
cated and the complex emotions that result, in the
same way that the theme of beauty rounds out a
significant thematic message, or the manufacture
of harmonious objects effects a technical whole.
The presence of the human figure and the play of
color in his work augment and enhance each other,
but do not undermine the seriousness of Veláz-
quez's striving for realism and truth that leads him
away from the excesses of drama—though it leads
him, perhaps, closer to God. In this sense, painting
the commonplace becomes a means of salvation.

In the life of a courtier-painter, the one pursuit
that really matters to us—even if his other accom-
plishments better enable us to understand the man
and some of his work—is the care with which he
harmoniously links places and environments, and

41

how, instead of losing them, he utilizes them in the painting. The essence of his genius lies in his ability to blend accuracy with interpretation in such a way that reality and truth are pictured on the canvas and yet are still subject to the exercise of the painter's craft. One has to love the world a great deal to exalt it, but one must also hate it a great deal to exorcise its truths. Between love and hate—that is where Velázquez's work lies. He makes room, in his work, for the presence of people and things, and for whatever the art of painting can draw from them. These elements are discernible if one can read between the lines and see beyond the spellbinding light effects which dissolve forms and reassemble them with the help of—and for—our eyes. Masses of color are set like so many precious stones from another world, a world that is nevertheless our own. Again, the words of Cézanne apply: "Art is a harmony that parallels nature. Art, like language, only has a raison d'être if it has *meaning*."

Let us now return to *Las Meninas*, which inspired Théophile Gautier's admiring question: "But where is the painting?" We recognize the painter figure as a character who, in his role as artisan, is set apart from the main activity of the painting but who nevertheless is an integral part of the harmony of the overall composition; he is the true king, being observed by the temporal king that we see reflected in the mirror. Through art, the painter rules over death as he once did over servitude: today he is the prince of a kingdom of accurately transfigured phantoms. And why would he have distorted them? He made the most obvious kind of reality into an object and a useful accessory in order to effect, on behalf of painting and of the real world, a connection between active reason and the vicissitudes of the visible universe which he equaled if not surpassed. In the end, one can easily see that, without a love and a fascination for appearances, Velázquez would have been merely a philosopher of truth, not a painter.

It bears repeating that Velázquez's kind of painting deals with the physical world of human beings and substances, as well as with the world of the intellect, the part of us that aspires to truth and beauty. But one aspect of his multifaceted style, upon which the painter elaborates, has remained unexamined: the subject of looking, by which artist and model, observer and observed, are at once at the center and on the periphery of a work that involves them (but never results in isolating them somewhere else). This pivotal dual position is central to a few great paintings in which—in keeping with the ideology of classical art—the painter seems willing to hold a mirror out to man, so that he might recognize in it himself and his yearning for a satisfying reflection (even if it is a truthful one). And yet, these works that seem so well-ordered and self-assured become like a broken mirror, appearing even more truthful by showing—without a display of vanity—their manipulation of form, the liberties taken as well as the restraints upheld. Thus, in a single stroke, painting gives rise to questions regarding history, recognized and accepted values, the meaning of life and art . . . all the rugged obstacles of reality and of obvious truths once they suddenly turn doubtful and uncertain.

But these *are* helpful obstacles, even if only for an instant, these rough and ever-changing appearances of things. Through them, the ridiculous endures, and the critical value of Velázquez's work is counterbalanced by a sensitivity that struggles with the surface appearance of objects and strives to give a moving, convincing impression of their immediacy through appropriate technical means. Perhaps each of us, depending on how we perceive and interpret what this great artist wrought from tangible reality, will encounter in Velázquez's oeuvre an echo of our own vision and sensibility. His work, lying somewhere between appearance and apparition, captivates us in every way: as we try to understand more fully the goal of Velázquez's painting, we become aware of his highly sensitive and delicate artistry that makes at least one life pulsate with emotion.

"There are as many worlds at our disposal," wrote Marcel Proust, "as there are original artists, worlds as different from one another as those that revolve in space, and whose special ray of light reaches us many centuries after leaving the source —call it Rembrandt or Vermeer—from which it emanated."

To those two exemplary names let us add that of Velázquez.

BIOGRAPHICAL OUTLINE

1599 JUNE 6: Baptized Diego Rodríguez de Silva y Velázquez in the church of San Pedro in Seville; probably born the previous day in the same city. He was the son of Jerónima Velázquez and Juan Rodríguez de Silva and, as is sometimes the case in Spain, took the name of his mother. His father, who had five children, traced his roots to a noble family from Oporto, Portugal, that had emigrated to Spain. His mother was a native of Seville.

1602 JUNE 1: Birth of Juana de Miranda Pacheco, in Seville, daughter of the painter and scholar Francisco Pacheco (1564–1644) and future wife of Velázquez.

1609 At the age of ten, Velázquez enters the workshop of Francisco Herrera the Elder (c. 1576–1656), where he apparently remained only a few months.

1610 DECEMBER 1: Velázquez becomes a student of Francisco Pacheco.

1611 SEPTEMBER 27: Francisco Pacheco receives Velázquez as a pupil in his studio, and signs a six-year contract with Velázquez's father. The master Pacheco was as renowned in Seville as a theoretician (he was author of *Arte de la Pintura*) as he was for his paintings. He counted among his friends the great sculptor Juan Martínez Montañés, as well as many artists, intellectuals, and ecclesiastical figures of the time, and was a Censor of the Inquisition. It was in this highly cultured environment that the young Velázquez was trained. Pacheco, steeped in Italian art himself, quickly recognized the talent of his pupil, and, far from imposing his own style or ideas upon Velázquez, he let him work in accordance with his own inspiration and paint from nature.

1617 MARCH 14: Having passed his examination—given by Pacheco and Juan de Uceda—Velázquez is recognized as a Master, and admitted to the painters' guild of Seville. Henceforth, he pursues his vocation with complete freedom.

1618 APRIL 23: Marries Juana Pacheco, his teacher's daughter, who will bear him two daughters: Francisca, baptized May 18, 1619, and Ignacia, born in 1621.

1620 FEBRUARY 1: As the owner of a workshop, Velázquez takes on Diego de Melgar as a student for a period of six years.

1621 MARCH 31: Death of King Philip III of Spain. Philip IV succeeds to the throne, and the Count-Duke of Olivares becomes prime minister.

1622 APRIL: Velázquez travels to Madrid, aided by

friends of his father-in-law, including Don Juan de Fonseca, a Sevillian who was chaplain of His Majesty's Chamber and a favorite of the Count-Duke of Olivares. This first journey proves to be a failure. Velázquez paints the portrait of the poet Góngora, but is unable to induce the king to pose for him.

1623 AUGUST: Fonseca recalls Velázquez to Madrid, and this time he paints a portrait of the king.
OCTOBER 6: Velázquez is named *Pintor de cámara* (Court painter), a title that corresponds to that of Painter to the king. Velázquez and his family settle in Madrid.

1625 He paints a portrait of Luis de Fonseca and probably also one of the Count Duke of Olivares.

1627 JANUARY: King Philip IV commissions each of his four painters—Vincenzo Carducci (Vicente Carducho), Eugenio Caxés, Angelo Nardi, and Velázquez—to execute a work representing *The Expulsion of the Moors from Spain* in which Philip III, who had ordered this expulsion, would be depicted. The winner was to be awarded the post of *Ujier de cámara* (Usher of the chamber). Although none of these paintings survives, we do know that Velázquez triumphed over his competitors.
MARCH 7: Official appointment of Velázquez to the office of *Ujier de cámara*. When, upon the death of Bartolomé Gonzalez, the post of Painter to the king becomes vacant, Velázquez, Carducho, and Caxés recommend that it be conferred upon Antonio de Lanchares.

1628 AUGUST: Rubens makes a second trip to Madrid and meets Velázquez. The two discuss artistic matters, and Rubens probably views *The Drinkers*, which is then in progress.
SEPTEMBER 3: King Philip IV orders that everything needed by Velázquez to execute the portrait of the late Philip III be put at the artist's disposal.

1629 JUNE 28: Probably on Rubens's advice, Philip IV gives Velázquez leave to depart for Italy.
JULY 22: The king issues a payment order to Velázquez for a painting of *Bacchus* (this is probably *Los Borrachos*, known as *The Drinkers*).
AUGUST 10: Velázquez sets sail from Barcelona.
SEPTEMBER 19: Velázquez arrives in Genoa (according to Pacheco). He proceeds to Milan and then Venice, where he is the guest of the Spanish ambassador Cristóbal de Benavente y Benavides, and then goes on to Ferrara, Cento, Bologna, and Loreto.
OCTOBER: Velázquez arrives in Rome, where he will stay one year and paint *Joseph's Bloody Coat Brought to Jacob* and *The Forge of Vulcan*.

1630 Toward the end of the year, Velázquez goes to Naples, where he meets his fellow Spaniard Jusepe de Ribera; then he returns to Madrid.

1631 JANUARY: Velázquez is in Madrid. He paints, among other works, the portrait of the Infante Don Baltasar Carlos and his dwarf (now in Boston).

1633 AUGUST 21: The artist's elder daughter, Francisca, marries Juan Bautista Martínez del Mazo (1612?–1667), who was then apprenticed to Velázquez.
Velázquez is appointed to the office of *Alguacil de casa y corte* (Constable of the royal household and the court).

1634 The artist is named *Ayuda de guardarropa* (Valet of the king's wardrobe), and is thereby authorized to transfer his duties as *Ujier de cámara* to his son-in-law, del Mazo.

1635 Velázquez completes *The Surrender of Breda*.

1638 Death of Vicente Carducho.

1639 MAY 10: Pacheco makes his last will and testament, naming his daughter Juana as residuary legatee.

1640 FEBRUARY 27: The king advances Velázquez five hundred ducats annually on account, toward works to be executed.

1642 SPRING: Velázquez accompanies the king during a few months' stay in Aragón.

1643 Velázquez is appointed *Ayuda de cámara* (Valet of the king's bedchamber) and, soon after, is named *Superintendente de obras reales* (Superintendent of the royal collections in the royal palaces), a post for which the artist receives sixty ducats monthly.
JUNE: Velázquez accompanies the king to Fraga.

1646 Velázquez is named *Ayuda de cámara con oficio* (Official valet of the king's bedchamber). From then on, he will thus occupy a relatively important position at court.

1647 MARCH 7: The painter is appointed *Veedor y contador de obras de la pieza ochavada de palacio* (Overseer and auditor of works in the octagonal room of the palace).

1648 The king increases Velázquez's annual advance to seven hundred ducats. Accompanied by his pupil Juan de Pareja, the artist leaves Madrid with a delegation charged with receiving the Archduchess Mariana of Austria (Philip IV's fiancée), the new queen, in Trent.
NOVEMBER 1: Arrival at Málaga.

1649 JANUARY 21: Velázquez and the delegation embark at Málaga.

FEBRUARY 11: Arrival at Genoa.

APRIL: Velázquez receives a payment order for eight thousand *reals*, the balance of the two thousand ducats provided by the king for the artist's travel expenses.

APRIL 21: Velázquez is in Venice as the guest of the Marquis de la Fuente, Spanish ambassador, entrusted with purchasing works of art for the king. (His acquisitions were to include paintings by Veronese and Tintoretto.) He visits Modena and Parma, proceeds to Bologna, arrives in Rome via Florence, and finally ends up in Naples.

JULY 10: Velázquez is again in Rome for a lengthy stay, during which time he will paint the portraits of Juan de Pareja and Pope Innocent X.

1650 FEBRUARY 17: Philip IV writes to his ambassador to the Holy See, advising him to arrange for Velázquez's return between May and June.

MARCH 19: Exhibition of the portrait of Juan de Pareja at the Pantheon, in Rome, where the portrait of Pope Innocent X will also be shown soon after.

Velázquez is admitted to the Accademia Nazionale di San Luca, in Rome.

JUNE 21: Another letter from Madrid requests Velázquez's return.

OCTOBER 3: Another urgent message.

1651 JUNE 23: Philip IV informs the Duke of Infantado that Velázquez has finally returned to Madrid. The artist brings back a number of important works to augment the royal collections.

1652 FEBRUARY 16: Philip IV names Velázquez *Aposentador de palacio* (Chamberlain of the palace), against the advice of a special five-member commission that had proposed other candidates.

MARCH 8: The artist takes the oath of office for the highest post he is ever to attain.

1653 FEBRUARY 22: Philip IV sends Velázquez's portrait of the Infanta María Teresa to the Viennese court.

1656 Velázquez paints *Las Meninas* (*The Maids of Honor*). He is put in charge of directing the arrangement of paintings and other works of art at El Escorial.

1658 JUNE 12: Through royal intervention, Velázquez is awarded the title of Knight of the Order of Santiago.

1660 APRIL 8: Velázquez departs for Fuenterrabía in order to decorate the royal residence on the Isle of Pheasants, where the solemn meeting of the Infanta María Teresa and her fiancé, King Louis XIV of France, is to take place.

JUNE 7: The ceremony at Fuenterrabía.

JUNE 26: Velázquez returns to Madrid.

LATE JULY: Velázquez becomes ill.

AUGUST 6: Death of Velázquez, at three o'clock in the morning.

AUGUST 7: Velázquez is buried in the parish church of San Juan Bautista with the honors befitting his position at court and his rank of Knight of Santiago.

AUGUST 14: Death of Velázquez's widow, Juana.

COLORPLATES

OLD WOMAN COOKING EGGS

c. 1618

Oil on canvas, 39 × 46"

Provenance: Sir J. Charles Robinson, London; Sir Frederick Lucas Cook, Baronet, Richmond, England; Sir Herbert Cook, Baronet; Sir Francis Cook, Baronet; acquired in 1955 for £57,000 by the National Gallery of Scotland, Edinburgh (no. 2180).

This painting, executed early in the artist's career, is generally believed to date from about 1618. It is one of the group of *bodegones,* or "kitchen scenes," that Velázquez painted in his youth, and that his teacher (and father-in-law), Francisco Pacheco, considered excellent training in pictorial representation. These kitchen scenes allowed the artist to combine simple objects, still-life elements—Spanish artists have always excelled in these—and the human form in a single work.

Before he became the outstanding portraitist at the court of King Philip IV, the young Velázquez painted such humble, ordinary folk as this *Old Woman.* Faces, expressions, attitudes, and gestures were somehow more straightforward, simpler, and more natural than in his later works. Indeed, the perception and transposition of his subjects onto the canvas were accomplished with greater facility by the young artist; both figures and forms were treated as objects. This artist, who would later be considered the veristic painter *par excellence,* already patiently displayed the need to "create truth," and the ability to effect a harmonious union in his work of the rather strong contrasts that existed between his usual models—common folk and everyday objects. From the very start, Velázquez rejected the anecdotal and everything picturesque. He knew, even as an apprentice, how to transform the commonplace into more than mere folk scenes, to portray life as art, suffused with the most vivid realism and, at the same time, with the subtlest poetry.

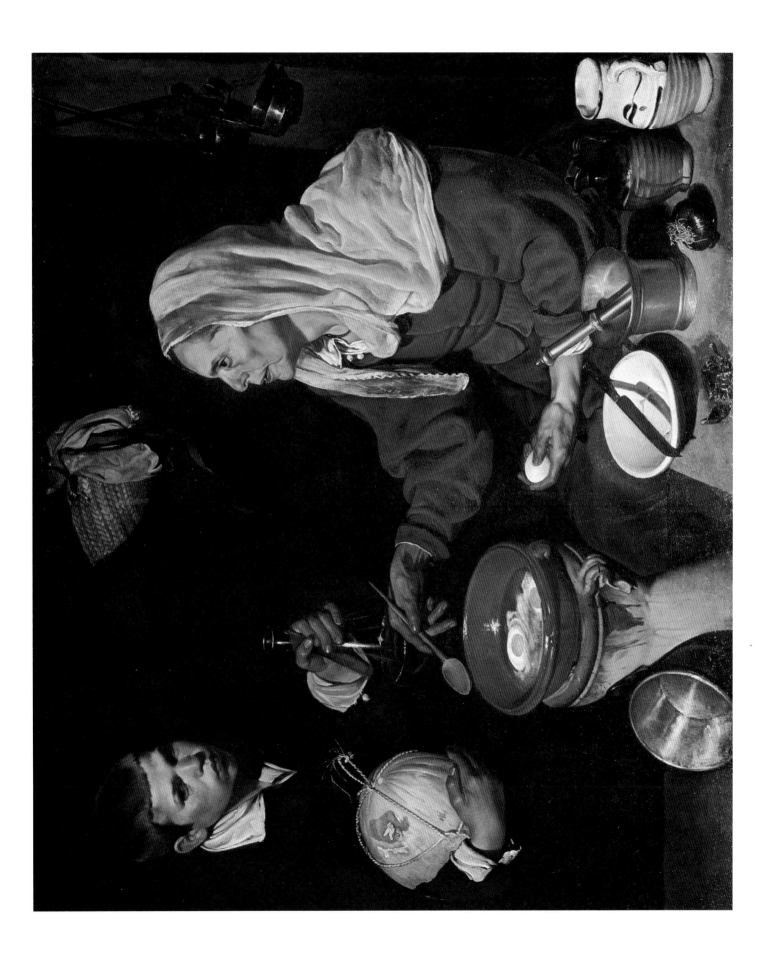

CHRIST IN THE HOUSE OF MARTHA AND MARY

c. 1618

Oil on canvas, 23 5/8 × 40 3/4"

Provenance: Lieutenant-Colonel Packe, Twyford Hall, Norfolk, England; Sir William H. Gregory, London (1881); National Gallery, London. Sir W. H. Gregory Bequest, 1892 (no. 1375).

This important work, dating from the artist's early years, is generally believed to have been painted about 1618.

The true subject of the painting is a religious one, Christ in the house of Martha and Mary, based on an episode in the Gospel according to Saint Luke (X: 38–42). The event itself is revealed to the observer by means of a visual device, thought by some art historians to be a mirror and by others a window. In any case, because the young Velázquez was fascinated by reality, he treated the subject essentially as a *bodegón*.

A robust, well-endowed peasant girl, very ordinary in appearance, is crushing garlic in a mortar. Behind her an old woman with a sober expression on her sharply lined face seems to be offering her culinary advice. The clothing of the women is unpretentious, its tones austere; there is no flashiness, no jewelry, no ornamentation whatsoever. The straightforwardness of the two women, the composure of their bearing and expression, and their sustained attention to their work are indications of their honest natures and their feeling for what is proper. However, the younger woman appears to be preoccupied by something occurring in front of her, which would imply that what we see in the background is, indeed, a mirror, in which is reflected Christ's visit to the house of Martha and Mary.

In the foreground at the right, on the table, are a plate of fish, another plate with two eggs, and a pitcher. Velázquez does not merely concentrate on their simple outward appearance, but probes the essence, the underlying poetry of all of these objects. They are not painted as purely decorative elements, nor are they isolated; each enters into a dynamic relationship with the others and is integrated into the composition as a whole. In this manner, they contribute to the harmony and overall rhythm of the work as well as to its reality and poetic significance.

And in the background there is the mirror-image of Christ's visit. In a luminous space, Christ is seated while one of the women kneels at his feet and the other remains standing, behind her.

Unlike Zurbarán, Velázquez never excelled as a mystical painter and was even less attracted to that popular religiosity, rooted more in superstition than in genuine religious fervor, to which Murillo was sometimes drawn. Incapable as he was of portraying anything devoid of reality, Velázquez's artistic vision thus interpreted religious themes with a Biblical simplicity infused both with realism and a mysterious poetry.

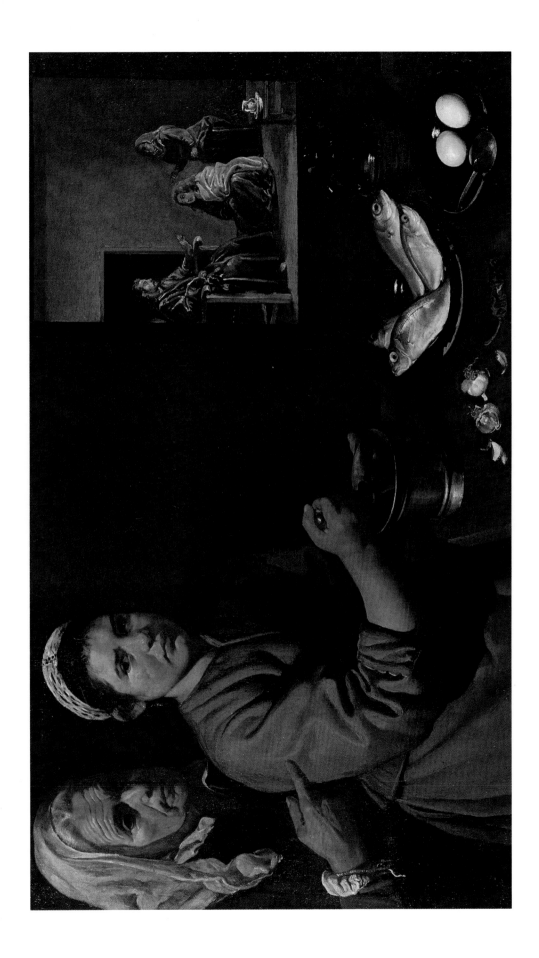

CHRIST IN THE HOUSE
OF MARTHA AND MARY, detail

The Spanish in general, and Velázquez in particular, excelled in their treatment of the still-life. In this detail, the various objects on the table in the foreground clearly indicate the importance bestowed upon them by the young Velázquez. The rhythm underlying their organization is in harmony with the overall atmosphere of the painting. The crucial point, however, is that these objects are not jumbled together; instead, the artist made a choice, a hierarchical arrangement influenced by the Spanish temperament, and by the customs and mores and popular lifestyle of Spain in his time.

Thus Velázquez does not position the objects at random, nor are they selected according to the dictates of a particular aesthetic vision. He puts them where they are because the arrangement corresponds to his need to present the truth—in this case, of the life of the Spanish family or of the typical Spanish inn. On the table, at the left, is the mortar in which the young peasant girl presses the garlic: the cloves are spread out over the table next to a pimiento, another spicy ingredient often used in Spanish cooking, that enables the artist, here, to add a bright red accent to the painting; a plate of fish about to be fried according to custom; and, lastly, another plate with eggs for making *tortillas*, those wonderful, typically Spanish omelettes. And there is an earthenware jug—not the *alcarraza*, used to keep water cool—for the hearty, aromatic wine whose perfume blends with the pleasant smell of the highly spiced foods.

Everything is simple. Nothing is overdone, affected. Velázquez would not have had any need for Picasso's haughty pronouncement: "I do not seek, I find!" He neither seeks nor finds, but simply observes and then paints life.

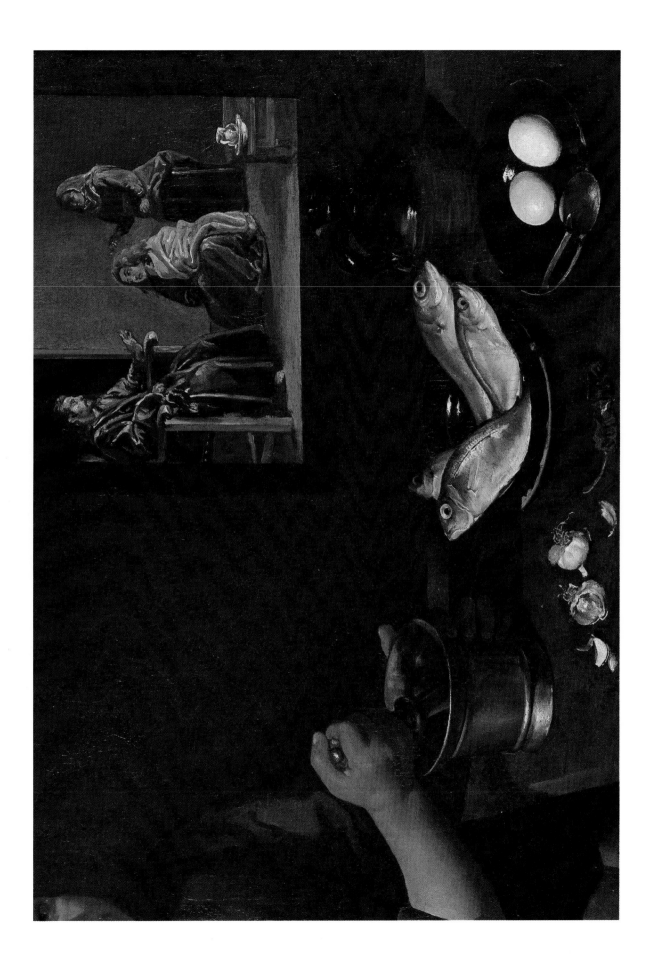

THE ADORATION OF THE MAGI

1619

Oil on canvas, 80 1/4 × 49 1/4"

Provenance: (since 1819) Museo del Prado, Madrid (no. 1166).

The date of this work is visible on a rock beneath the feet of the Virgin. Some read the inscription as 1617, but it is more widely believed to be 1619.

Charles B. Curtis suggests, but cannot confirm, that this painting may be the same one that Richard Twiss mentioned (*Travels in Portugal and Spain*, London, 1775, p. 308) was in the possession of Don Francisco de Bruna of Seville.

According to José López-Rey, the canvas was originally wider; Elizabeth du Gué Trapier cites a lithograph by Cayetano Palmaroli (published in 1832) whose composition does, indeed, confirm this theory.

The painting has belonged to the Prado since 1819, when, as noted in the museum's 1920 catalogue, it was transferred from the Escorial where it had been mistakenly attributed to Zurbarán. Some art historians claim that it was painted for the Novitiate of San Luis of the Jesuits in Seville.

This straightforward and direct scene is yet another example of the objective realism of the young Velázquez's style. Moreover, it has been suggested that he selected his models from among those closest to him: one or the other of the Magi is thought to be the artist's father-in-law, Francisco Pacheco; the youngest of the Magi, Velázquez himself; the Virgin Mary, Juana Pacheco (Velázquez's wife); and the infant Jesus, one of the artist's daughters. Here, again, a religious subject is treated with the utmost restraint.

If one compares the *Adoration* with similar works by two of Velázquez's contemporaries, Zurbarán and Murillo, one becomes acutely aware of the differences between their respective treatment of religious themes. Zurbarán's works, although also inspired, at the outset, by a desire for realism, are imbued with a high degree of mystical fervor and are extremely monastic in character: the pronounced spirituality and intensity of expressions are the antithesis of the direct realism of Velázquez's early work. The paintings of Murillo, on the other hand, were inspired by the Jesuits, and the outward signs of religiosity are in marked contrast to the serenity of a typical Velázquez "slice of life," such as he attains here.

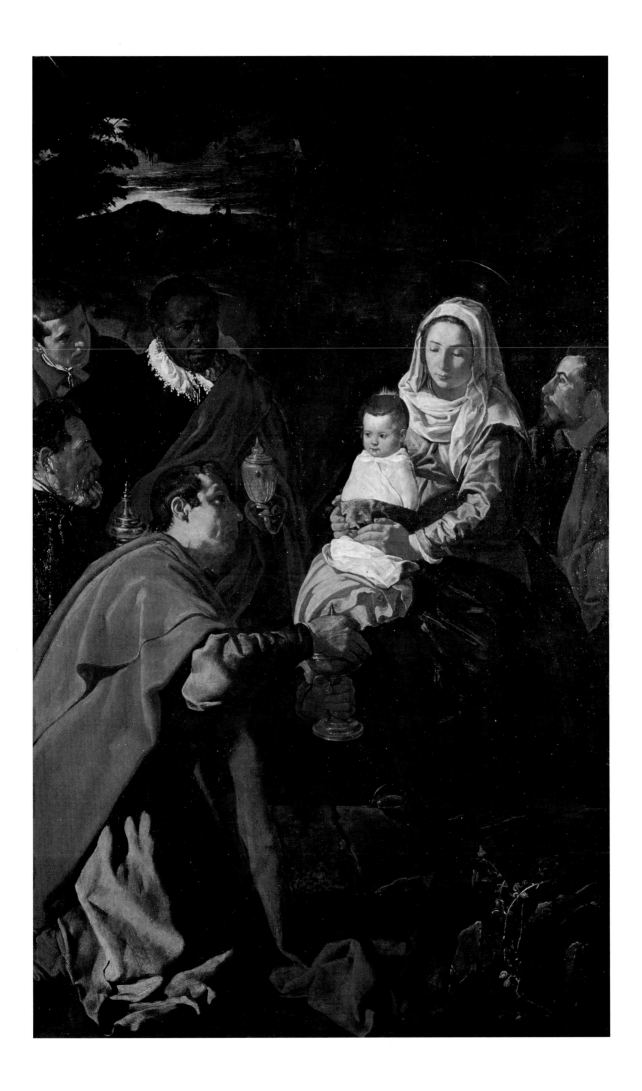

SAINT JOHN THE EVANGELIST ON THE ISLAND OF PATMOS WRITING THE APOCALYPSE

1618–19

Oil on canvas, 53 1/4 × 40 1/4"

Provenance: Probably the pendant to The Immaculate Conception, *both of which were originally in the Chapter House of the Convent of the Calced Carmelites, Seville; (according to López-Rey) Collection of Manuel López Cepero, president of the Academia de Bellas Artes, Seville, who sold both paintings in 1809; Bartholomew Frère, British Minister to Spain, London (1809); heirs of Bartholomew Frère, London; Mrs. Woodall and the Misses Frère, London; acquired in 1956 for £50,000 by the National Gallery, London (no. 6264).*

Most art historians date this painting somewhere between 1618 and 1619; in any event, it was executed early in the artist's career. A few experts, such as Martin Soria, even detect a certain stylistic affinity to Luis Tristán.

Juan Allende-Salazar has proposed that the *Saint John*, as well as certain other works of Velázquez's youth, is a self-portrait, but this opinion has been rejected by the majority of experts today. César Pemán theorizes that this is impossible because of the direction of the subject's glance, which could not have resulted from a mirror-reflection of the model.

In accord with painting techniques at the time, the style is characterized by chiaroscuro effects—rather strong contrasts in the interplay of light and shadow —and by broad, rather simplified planes that give forceful definition to the forms by modeling them in high relief. The face, its expression simple and direct, is modeled by means of such broad planes, the paint applied in bold brushstrokes. At about the same time, the Dutch painter Frans Hals employed a similar technique. Later, during the age of Impressionism, Édouard Manet would treat the human form, and especially the faces of his figures, in much the same manner.

The beauty of the color harmonies—based on oranges, browns, and whites, with a few subtle accents of red—endows the work with stylistic unity and a powerful intensity.

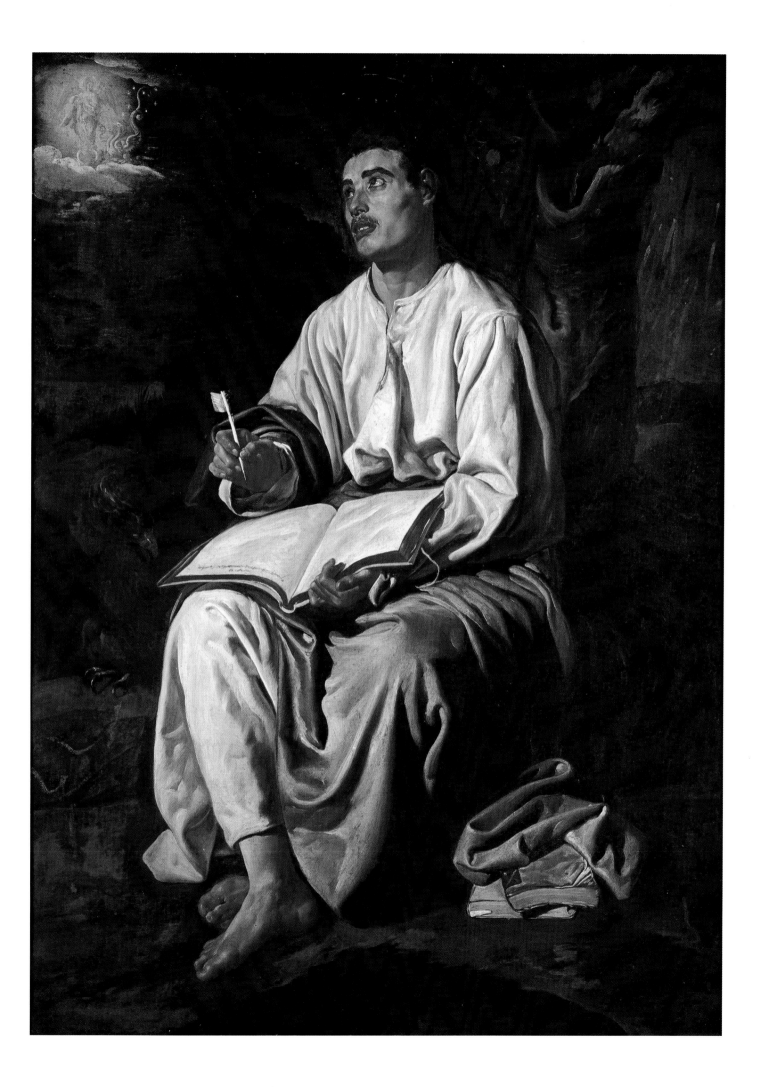

THE WATER CARRIER
or THE WATER SELLER OF SEVILLE
(EL AGUADOR DE SEVILLA)

1619–20

Oil on canvas, 41 3/4 × 32 1/4"

Provenance: Don Juan Fonseca y Figueroa (d. 1627), Madrid; Gaspar de Braca-monte, Madrid; Cardinal Infante Don Fernando, Madrid; Palacio Real del Buen Retiro, Madrid (inventory of 1701: "El Corzo, aguador"); New Palacio Real, Madrid (by 1754; listed in inventories of 1772, 1794); in the possession of Joseph Bonaparte, but lost to the Duke of Wellington at the battle of Vittoria in 1813; subsequently presented to the duke by Ferdinand VII of Spain; Duke of Wellington, Apsley House, London; Wellington Museum, Apsley House, London (no. 1600).

Most art historians date this work between 1619 and 1620. (It was restored in 1959.) The writings of Antonio Palomino in the eighteenth century note that this painting was in the royal collections of the Palacio Real del Buen Retiro as early as 1701 when it was listed in the inventory, and a description of the work was given in which, José López-Rey writes, only two of the three figures in the composition are mentioned; López-Rey provides an English translation of Palomino's original Spanish: "The painting called the Waterseller, who is an old man very shabbily dressed in a sordid and ragged smock, which would dis-cover his chest and abdomen covered with scabs and hard, strong callouses. And beside him there is a boy, to whom he is giving a drink. This work has been so talked of that it has been kept to this day at the Palace of the Buen Retiro."

The painting's first owner, Don Juan Fonseca y Figueroa, an admirer and patron of Velázquez and chaplain to King Philip IV, died in Madrid on January 15, 1627. The day after his death, Velázquez appraised the work at 400 *reals*; it was subsequently purchased by Don Gaspar de Bracamonte for 330 *reals*, and soon after was acquired by Cardinal Infante Don Fernando.

Writing under the pseudonym "Un vago italiano" (*Lettere*, 1764), Father N. Caimo mentions this important work, and notes that it is "drawn and col-ored with great refinement."

At least three other versions of the painting are known to exist: one, in the Contini-Bonaconi Collection in Florence, is generally considered a copy, al-though José Gudiol Ricart sees it as a preliminary work probably executed about 1618, prior to the canvas under discussion here; a second, described by López-Rey as very similar to the first variant, was discovered by New York art dealers in 1953; a third, considered inferior in quality to the other two versions, is in the Walters Art Gallery in Baltimore.

The young man in the painting reproduced here is reminiscent of the boy in *Old Woman Cooking Eggs* (colorplate 1) and of similar figures in other works from the artist's early years. The beauty of the rendering and of the surfaces of the objects is remarkable. The virtuosity of the artist's technique is especially apparent in the water jug (or *alcarraza*) in the foreground, the transparency of the glass, and the clarity of the water it contains: in a stroke of genius, Velázquez clouds the glass and thus succeeds in conveying the water's freshness and purity.

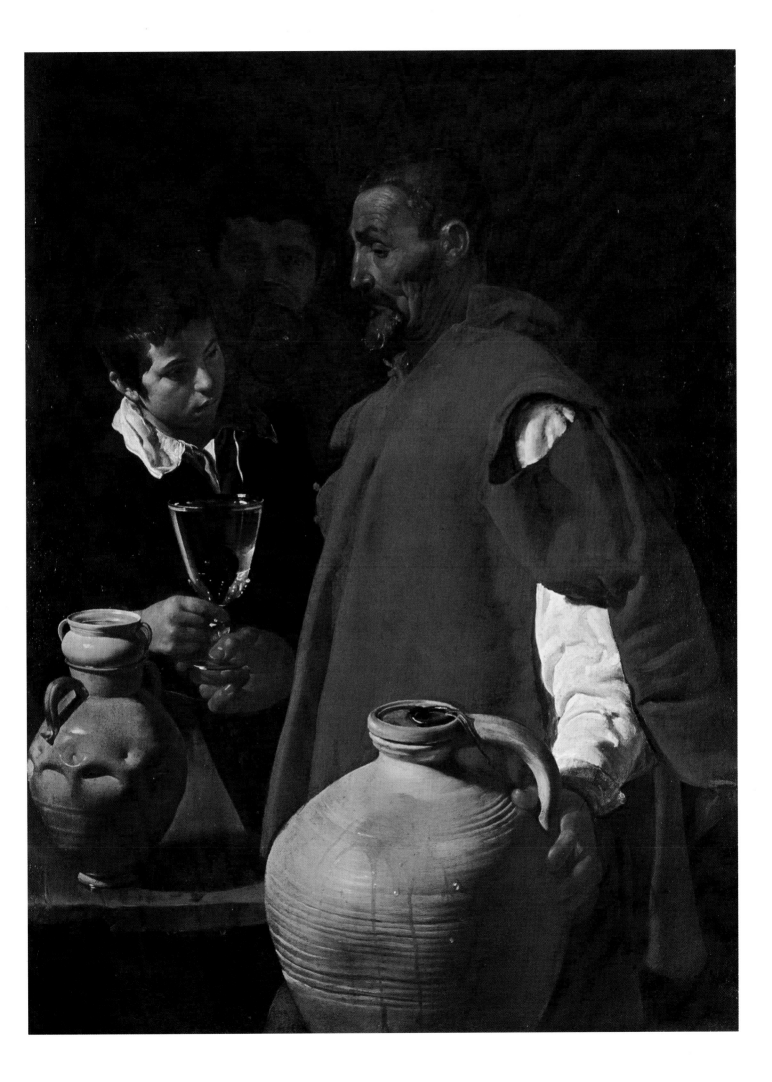

THE POET DON LUIS DE GÓNGORA Y ARGOTE

1622

Oil on canvas, 20 1/8 × 16 1/8"

Provenance: Possibly the same portrait listed among Velázquez's possessions at the time of his death (inventory no. 179); Marqués de la Vega Inclán; Tomás Harris Ltd., London (according to López-Rey); (since 1932) Museum of Fine Arts, Boston. Maria Antoinette Evans Fund (no. 3279).

Luis de Góngora y Argote, born July 11, 1561, in Córdoba—where he died May 23, 1627—is considered one of the most representative of the poetic geniuses of his day. Possessed of a superior intellect, he reacted against facile creativity, and his desire to address himself to the cultured classes led him to found the school of "cultism." His style—termed "Gongorism"—is regarded by some as precious, even a bit hermetic. However, the *Romances* and *Letrillas* (published between 1580 and 1605) reveal that, despite a surface refinement, Góngora's art was not entirely bereft of those concise but accurate picturesque popular visions peculiar to the Spanish people. Góngora's sonnet for the tomb of El Greco bears out the artistic kinship between these two masters: lyricism; singularity of expression; elongation of the poet's syntax, and of the painter's figures; Baroque yet heroic naturalism. In addition, their destinies were parallel, for their fame often generated strong opposition, especially in some official circles.

This portrait was painted at the request of the artist's father-in-law, Francisco Pacheco—who mentions it in his writings (vol. 1, p. 156)—during Velázquez's first trip to Madrid in 1622. Pacheco liked to surround himself with people of distinction, from every field of accomplishment. His studio was thus an important training ground for his students, not least among them Velázquez.

Velázquez's rendition of the poet is quite restrained: the face is highly structured and depicted with a profound psychological insight that reflects the exactitude and, at the same time, the subtlety of the subject's intellect.

The nearly identical portrait of Góngora in the Museo del Prado is believed, today, to be a studio copy. A similar copy is in the Museo Lázaro Galdiano, Madrid, and other copies may be found in the Meadows Collection in Dallas and in the Jaúregui Collection in Bilbao, Spain.

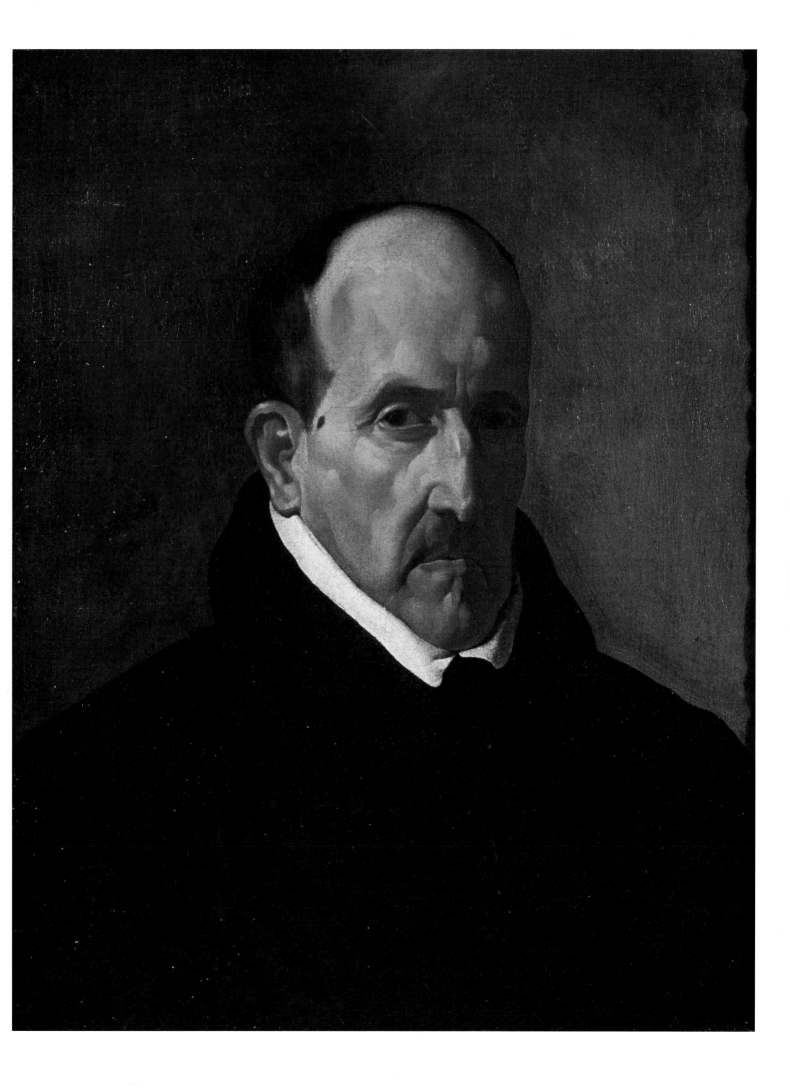

THE VIRGIN PRESENTING THE CHASUBLE TO SAINT ILDEPHONSUS

1623

Oil on canvas, 65 × 55 1/8"

Provenance: Church of San Antonio, Seville; Palace of the Archbishop, Seville.

This painting dates from 1623, according to most art historians. There is a tendency to categorize Velázquez exclusively as a portraitist, but, in any case, it is an incorrect assumption to regard his religious compositions—more numerous than one might think—as of only minor importance, lacking in the degree of religious feeling and mysticism that characterizes the work of his predecessors, his contemporaries, and his followers. In our opinion, this belief is unfounded. The majority of Velázquez's religious paintings, though they seem, on the surface, infused with the fascinating reality of ordinary folk, are nevertheless filled with a deep religious feeling that transcends this realism. Like his fellow Spaniards, he would not have been able to escape these two major tendencies. Thus he explored a theme that was especially meaningful to many Spanish artists (notably Fernando Gallego, Jacomart Baco, the Master of St. Ildephonsus, El Greco, Murillo, and Juan de Valdés-Leal) and that Rubens himself had painted after his second trip to Spain in 1628—the handing over, or rather the presentation of the chasuble to Saint Ildephonsus. Saint Ildephonsus was born in Toledo in 607 (and died there in 667). He succeeded his uncle, Eugenius II, as Archbishop of Toledo, in 657. The author of numerous works in Latin, Saint Ildephonsus, whose feast day is January 23, is still among the most popular saints in Spain. One day he had a vision that the Virgin Mary, recognizing him, placed upon him a holy chasuble.

As with other earlier paintings by Velázquez, it has been suggested that the Virgin Mary's features are those of Juana Pacheco, while the angels are thought to be portraits of several young women of Seville. In spite of the deteriorated condition of this painting, Aureliano de Beruete positively identified the work as a genuine Velázquez in his 1898 monograph on the artist. Cleaning and restoration in 1960 enhanced the value of the canvas and, a certain amount of damage notwithstanding, revealed once again its true quality (see Diego Angulo Iñíguez, *Archivo Español de Arte*, vol. 33, April–September, 1960, pp. 290–91). In his 1969 book, Pietro Maria Bardi points out that Palomino had already detected in Velázquez's work the triangular arrangements of El Greco, and that José Camón Aznar sees ties to Caravaggism.

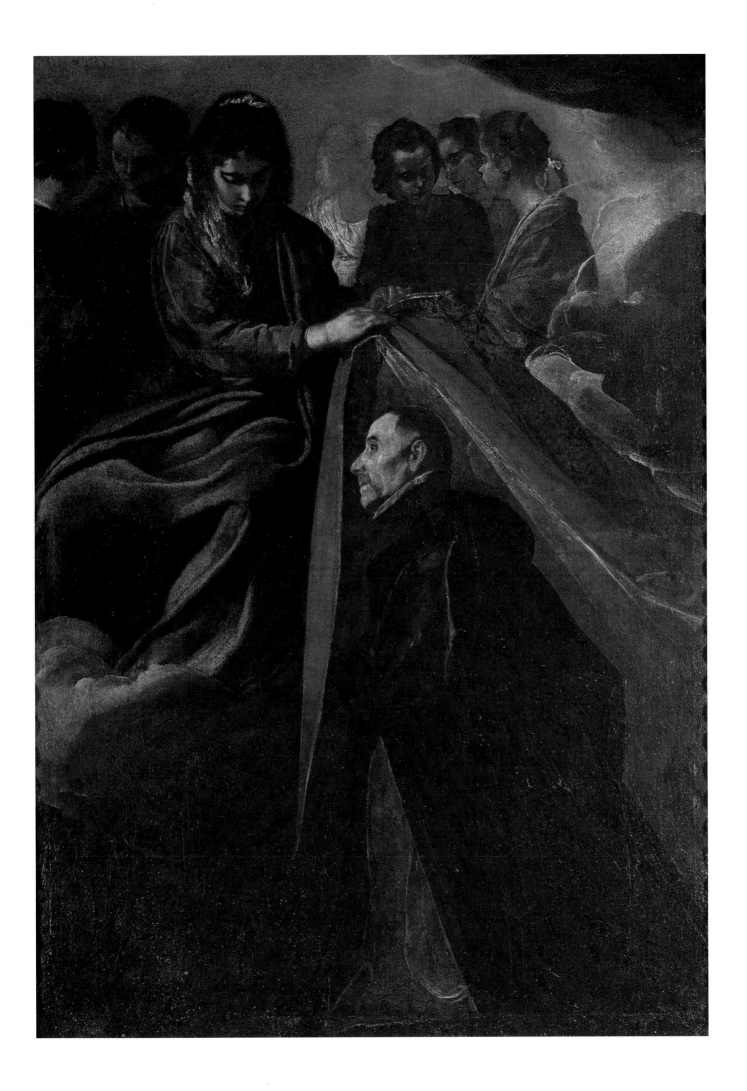

CHRIST AT THE COLUMN, or CHRIST AFTER THE FLAGELLATION CONTEMPLATED BY THE CHRISTIAN SOUL

c. 1629-32

Oil on canvas, 65 × 81 1/4"

Provenance: Acquired in 1858, in Madrid, by the English diplomat John Savile Lumley (later Sir John Savile Lumley and Baron Savile), and given by him to the National Gallery, London, in 1883 (no. 1148).

López-Rey believes that this painting was executed about 1626–28. However, most art historians—especially Bardi—agree that it was painted after the artist's first trip to Italy (1629–30), and thus date it 1632 by virtue of its stylistic affinity to *Joseph's Bloody Coat Brought to Jacob* and *The Forge of Vulcan* (colorplates 12, 13). Bardi notes further that one can perceive this "man of sorrow" as reminiscent of Michelangelo's *Christ* in Santa Maria sopra Minerva in Rome, though idealized in the manner of Guido Reni.

The subject matter appears to be complex, but there again opinion is divided. Some interpretations hold that it is a version of the traditional theme of "Christ at the Column," which originated as a vision beheld by Saint Bridget of Sweden as a child. However, a more recent hypothesis now seems to prevail, which lends credence to the present title of the work, *Christ After the Flagellation Contemplated by the Christian Soul*. According to this explanation, the little girl is no longer seen as Saint Bridget of Sweden, but as an allegorical representation of the soul—the devout soul—in pious ecstasy before the Passion (this opinion, proposed by F. Schweides in 1905, has been supported since then by other art historians, including López-Rey). This does, indeed, seem to be more in keeping with the mystical teachings of the time, and of Saint Ignatius Loyola's words in particular: "Weep for me, O my soul, for it is thou who hast punished me thus."

This theme had been depicted by several painters from Seville, notably by Juan de Roelas, whose interpretation, designed for the Convent of the Incarnation in Madrid, was very similar to Velázquez's although the compositions differed. Karl Justi mentions another painting of the same subject in the Church of la Merced Descalza at Sanlúcar de Barrameda, Spain. In the painting reproduced here, critics have again noted that the angel bears a striking resemblance to the artist's wife, Juana Pacheco, and that the soul is actually modeled after one of his daughters.

Two preparatory drawings may be associated with this painting: one is of the head of the Redeemer (Biblioteca Nacional, Madrid); the other, of the angel, was formerly in the Instituto Asturiano Jovellanos, in Gijón, Spain, but was unfortunately destroyed along with the rest of the collection during the Spanish Civil War in 1936–39.

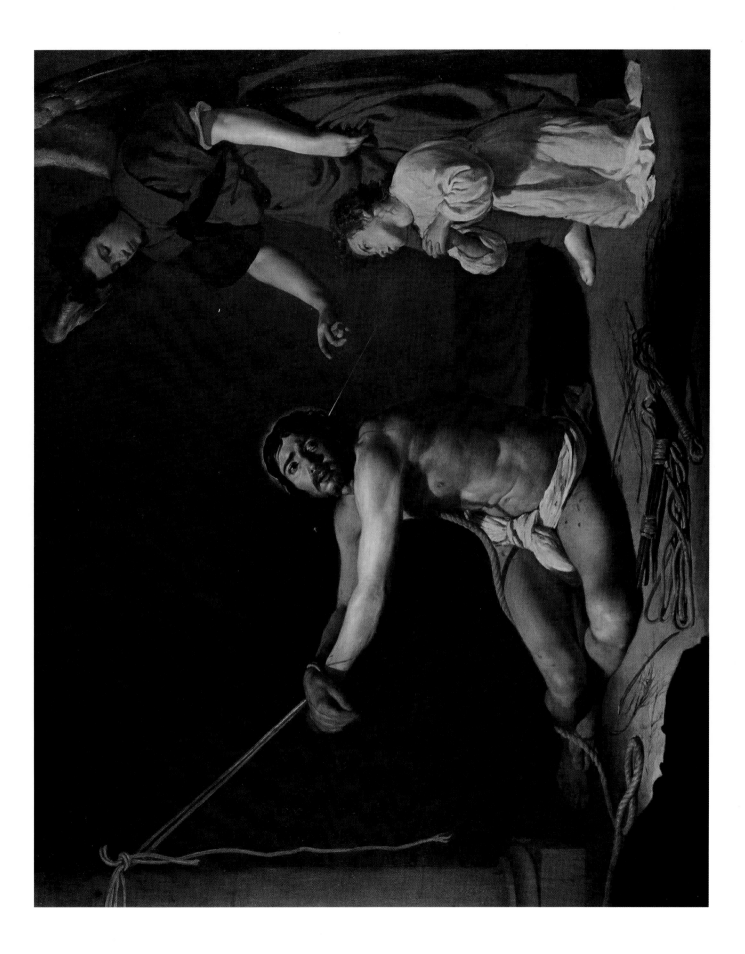

LOS BORRACHOS (THE DRINKERS)

c. 1629

Oil on canvas, 65 × 88 3/4"

Provenance: Real Alcázar (inventories of 1636, 1666, 1686, 1700); Palacio Real del Buen Retiro, Madrid (after the 1734 fire); New Palacio Real, Madrid (inventories of 1772, 1794); (since 1819) Museo del Prado, Madrid (no. 1170).

This famous work was executed in Madrid between the summer of 1628 and the departure of the artist for Italy, which was at about the same time as Rubens's diplomatic mission to King Philip IV on behalf of the Infanta Isabella and the Marqués de Spínola. Rubens arrived in Madrid in July, 1628, and, during the several months that he spent there, sought out Velázquez's company rather assiduously. August L. Mayer, however, thinks that the painting was retouched by Velázquez after his return from Italy. In any case, there exists a payment order for one hundred ducats, issued by Philip IV, dated July 22, 1629.

As early as 1636, the inventories of the royal collections in Madrid list the painting reproduced here; the oldest among them refer to it as *The Triumph of Bacchus*. There is no need to stress the major importance of this work, since it was already acclaimed during the artist's lifetime.

In the same way that Rubens excelled in blending allegory and mythology with reality or history, here a mythological personage (Bacchus) is shown with satirical figures or characters drawn from picaresque novels (his disciples).

Some have interpreted the painting, which shows Bacchus, seated on a wine barrel, placing a crown of leaves upon the head of a kneeling man, as a parody of a mythological scene. Others have proposed that there was a satirical intention, a reference to some literary work, or perhaps the evocation of a harvest festival which might have taken place in Brussels in 1612. But how could Velázquez—who had never been to Flanders—have witnessed this festival? Through engravings? Or from descriptions by Rubens or by others? In any case, the references to Flanders are nevertheless rather obvious: With regard to the head of Bacchus, Diaz de Corral, in particular, has cited the engraving by Hendrik Goltzius after the *Bacchus* by Michelangelo (Museo Nazionale del Bargello, Florence).

According to Aron Borelius, *Los Borrachos* is a mixture of the painting style of Rubens with picaresque elements from Ribera; in the opinion of Bardi, it is a faithful adaptation by Velázquez of a theme similar to those favored by Rubens or, at least, of one of the Flemish master's characteristic figures. Caravaggesque influences made themselves felt fairly early in Spain, and we can see evidence of this in the apparent resemblance between the Bacchus of Velázquez and those of Caravaggio (Galleria Borghese, Rome; Galleria degli Uffizi, Florence).

There is a copy of this important work in the Gallerie Nazionali di Capodimonte in Naples (where it has been since the seventeenth century). Its fame derives from the fact that some historians, going against the consensus of opinion, believe that it might have been at least partially painted by Velázquez himself. Many other paintings after originals by Velázquez do exist, but these can be considered only as later copies.

66

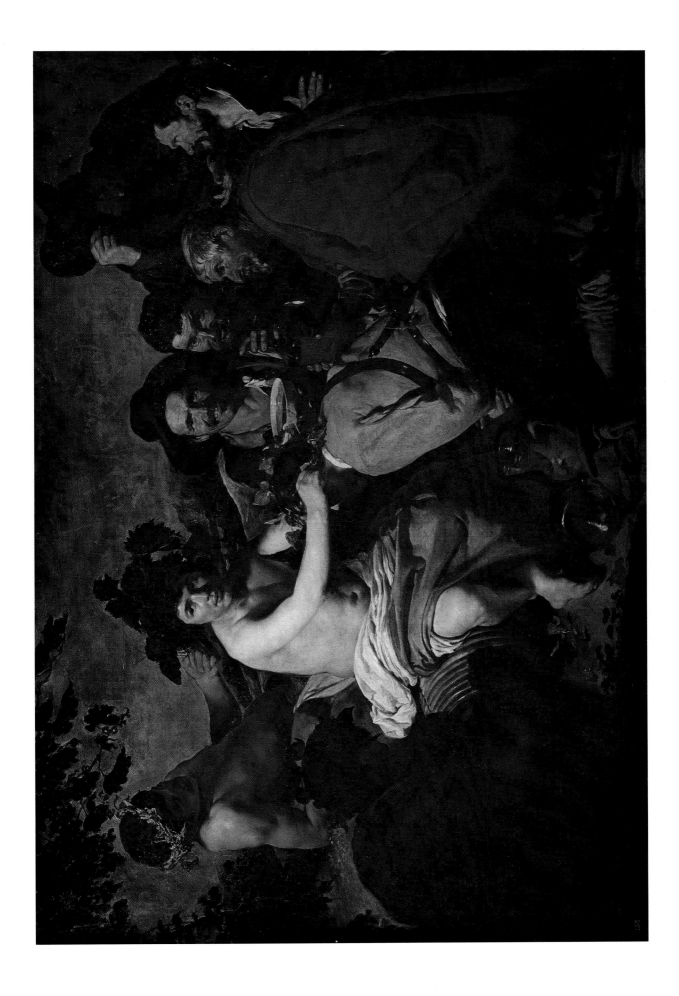

LOS BORRACHOS
(THE DRINKERS), detail

Although in the discussion accompanying the preceding plate we have seen that this painting of *The Drinkers*, one of Velázquez's masterpieces, was deeply inspired by Flemish art, particularly that of Rubens, as well as by Caravaggio and his followers, it is no less true that it remains typically Spanish in feeling.

If we study the complete painting, and then focus in on such specific details as the heads of the figures in the center and at the right side of the composition, a close link to the picaresque novel of the day is evident.

But what exactly is the *picaro*? The word is used in Spanish to describe a rogue or beggar who keeps company with ruffians and vagabonds. When used as an adjective, it is synonymous with "ragged" or "tattered." The ubiquitousness of begging in mid-sixteenth-century Spain is, perhaps, one explanation for the blossoming of the form about 1600.

The sixteenth-century Spanish novel *La Celestina* appears to have first introduced this literary genre to the Iberian peninsula, but it was *La Vida de Lazarillo de Tormes* (by Diego Hurtado de Mendoza; 1554) that marked the true beginning of the picaresque novel. The tale of this lazy and destitute rogue serves as a perfect reminder of the indolent, mischievous urchins later painted by Murillo.

Guzmán de Alfarache, written from 1599 to 1604 by Mateo Alemán, continued that literary genre which reached its zenith with the *Historia de la Vida del Buscón* of Francisco Gómez de Quevedo y Villegas (published in Saragossa, Spain, in 1626). The latter drew powerful effects from its leitmotif of hunger, and we cannot help but connect certain scenes in the book with Velázquez's paintings of *bodegones*.

And, finally, Cervantes (1547–1616) himself was drawn to the picaresque form over and over again, notably in certain of his *Novelas ejemplares* (*Exemplary Tales*) of 1613.

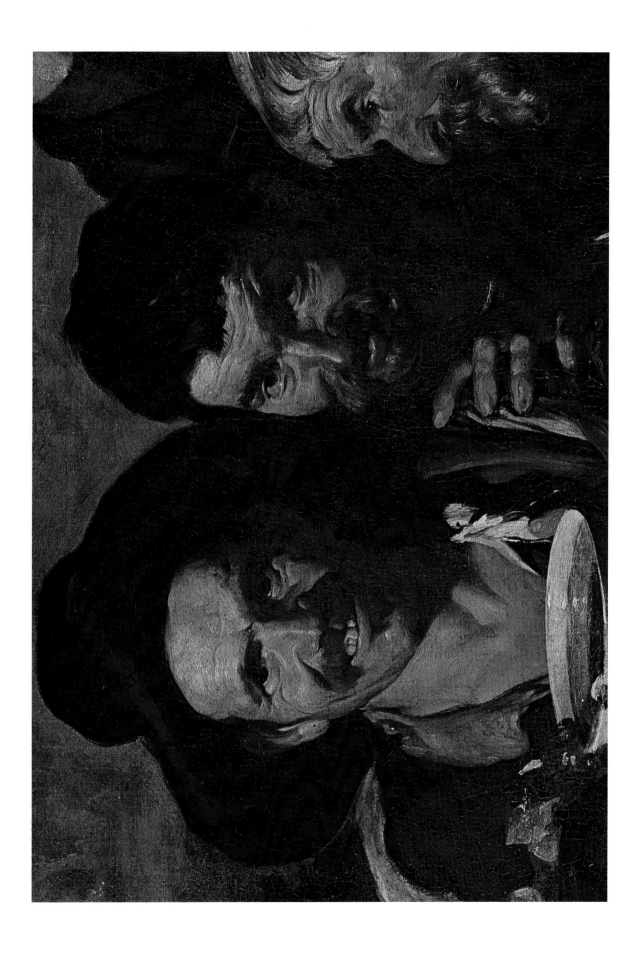

JOSEPH'S BLOODY COAT BROUGHT TO JACOB

1630

Oil on canvas, 7' 2 1/8" × 9' 5 1/4"

Provenance: Acquired, together with The Forge of Vulcan, *by the Count-Duke of Olivares, who presented them to King Philip IV of Spain; both paintings placed in the Palacio Real del Buen Retiro, Madrid, c. 1637, by Philip IV; Monastery of El Escorial (since 1665); confiscated by Joseph Bonaparte in 1810 and sent to Paris, where it was exhibited at the Musée Espagnol; returned to the Monastery of El Escorial, 1815.*

According to Palomino, this work was painted in Rome in 1630—at the same time, and using the same models as *The Forge of Vulcan* (colorplates 13, 14).

Certain art historians have seen in this painting Italian—in particular, Bolognese—influences that appear rather irrefutable. However, in its composition, the painting lacks that quest for harmony so characteristic of the Italians. The figures are arranged not with a care toward beauty but for truth. They seem to have been caught in the act of conversation, accusation, or self-defense: it is a discussion that is depicted here, more than the interpretation of a Biblical theme. Thus the artist enlisted his imagination in an effort to portray the truth behind his subject matter, instead of what was mere probability or likely to be believed. That is why Velázquez was so profoundly original for his time—and why he remains so today—for his genius refused to bow to the norms and the more or less arbitrary rules of what are considered the basic aesthetic principles. He was, in effect, an artist who set himself apart by his ability to reveal the truths underlying the mystery of life, without additions or restrictions.

Mayer mentions that there is a studio copy of this work in a private collection in Madrid that is a faithful reproduction, although, as a result of restoration in 1953, the original canvas as it now exists is slightly smaller on the right and left sides. There are other copies in various Spanish collections. According to Bardi, Manuel de Gallegos dedicated seven rather bombastic verses of his *Silva topográfica* (1637) to the original painting.

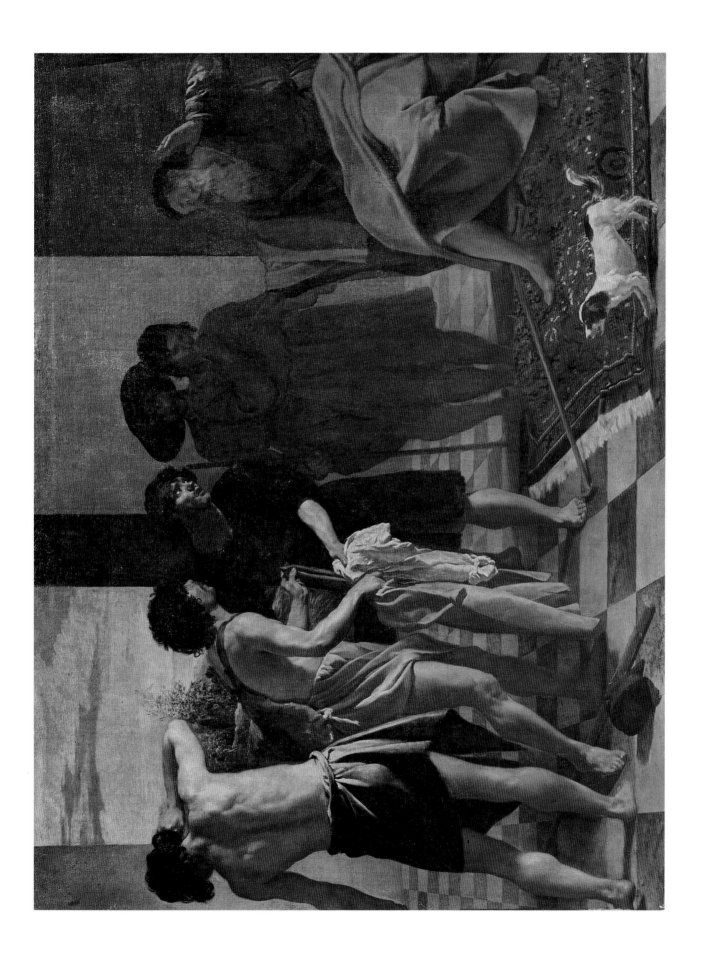

THE FORGE OF VULCAN

1630

Oil on canvas, 7' 4 1/8" × 9' 6 1/2"

Provenance: Bought, together with Joseph's Bloody Coat Brought to Jacob, for King Philip IV in 1634 by Don Jerónimo de Villanueva, Protonotary of Aragón, and secretary to the Count-Duke of Olivares; Philip IV placed both works in the Palacio Real del Buen Retiro, Madrid (inventory of 1701); New Palacio Real, Madrid (inventories of 1772, 1794); (since 1819) Museo del Prado, Madrid (no. 1171).

As noted in our discussion of *Joseph's Bloody Coat Brought to Jacob* (colorplate 12), Palomino believes that Velázquez completed both paintings at the same time and place (Rome, 1630), and with the same models.

This scene blends myth and reality. The vision of Apollo—whose head, seen in profile, is encircled by a halo formed by the golden rays of a blaze of sunlight—lends a somewhat dreamlike air of unreality to the god's countenance. His bearing is very different from the simplicity of attitudes, gestures, and expressions of the other figures, especially Vulcan, who here is portrayed as a humble blacksmith. The realistic reddish glow of the fire in the forge in the background contrasts sharply with the brilliance of the golden yellow solar rays, almost unbearable in their intensity.

Bardi believes that Apollo is revealing the adultery of Venus and Mars, thereby interrupting the work of Vulcan and his aides who are busy forging the armor of a knight of intermediate rank: the usual desacralization of the myth. And he adds that Angulo Iñiguez observed that "the mythological motif here assumes a moral significance not usual in the work of artists during the Renaissance but which may be found in the satirical interpretations of poets of the time or shortly thereafter." Pedro Calderón de la Barca, in particular, in *La hija del aire*, appears to recall the tone of this work, for the gracious Chato, noticing the liberties his wife takes with a soldier, ironically invokes Vulcan.

It is interesting to compare this painting by Velázquez with Louis Le Nain's (1593–1648) famous portrayal of *Venus at the Forge of Vulcan* (c. 1641) in the Musée Saint-Denis, Reims. Although the two works are nearly contemporaneous, neither artist could have seen the work of the other. The treatment of the subject of each, is, however, very similar, as much in spirit as in form and technique. Each master most certainly retains the stamp of his own individuality, although Le Nain's composition is more concentrated and Velázquez's has a greater feeling of space.

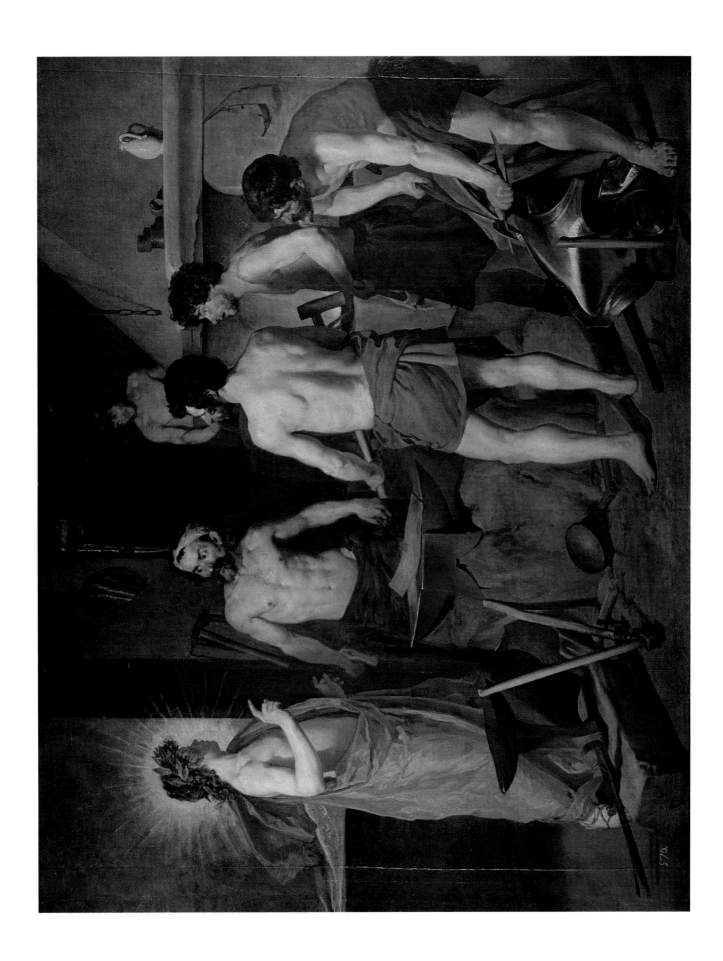

THE FORGE OF VULCAN, detail

The theme of the forge is particularly interesting when we realize that it was developed in the first half of the seventeenth century, especially in painting, and specifically by Velázquez and Louis Le Nain. Not only the ordinary man, but even the peasant was to play a role in the iconography of the time. It is not without interest to note that, in France in particular, Le Nain concerned himself with the problems of the peasants well before the writers did. We are aware of Jean de La Bruyère's (1645–1696) celebrated passage about peasants, and of the works of Madame de Sévigné and La Fontaine. Le Nain anticipated their writings, for he knew how—as Velázquez had done only a few years before him—to skillfully reveal both the nobility of attitude of the peasants that lay disguised beneath their outward appearance of degradation, and even a certain shrewdness which was apparent in the gleam in their eyes.

A comparative study of certain figures in the Velázquez painting and in Le Nain's *Venus at the Forge of Vulcan* is extremely enlightening. We should add here that Le Nain executed still another painting, in a smaller format, entitled *The Forge* (Musée du Louvre), that may also be compared with interest to Velázquez's canvas despite the absence, in this case, of those mythological elements that figure in Le Nain's other version of the same theme.

The forge, which was located in the countryside—or occasionally even in the city—served as a meeting place for ordinary folk to discuss their problems, and the children invariably gathered around them there, fascinated by the marvelous attraction of the fire in the forge, and its sudden, momentary bursts of light that danced about the room.

In addition, since the time of Caravaggio and then of his imitators, who comprised the Luminist or Tenebrist movement in seventeenth-century Europe, it has been known how strongly vigorous contrasts—light *vs.* shadow—excited the imagination, while permitting artists to re-create a world that was real and at the same time mysterious. Through the use of such dramatic contrasts, the faces of the figures in Le Nain's *Forge*, as well as those in Velázquez's painting —such as the face seen here—are set off in striking relief, their extremely realistic expressions heightened by reflections of light, or lost in mysterious shadow.

DON BALTASAR CARLOS
AND HIS DWARF

1631

Oil on canvas, 55 1/8 × 31 7/8"

Provenance: Acquired in Italy by the Earls of Carlisle (c. 1750), and kept at Castle Howard, in North Riding, Yorkshire, England, until the middle of the nineteenth century; Museum of Fine Arts, Boston. Henry Lillie Pierce Fund, 1901 (no. 01.104).

In the early nineteenth century, when this painting was still at Castle Howard, it was entitled *The Prince of Parma with His Dog* and attributed to Correggio. Gustav Friedrich Waagen identified it as the work of Velázquez in 1854. Karl Justi is responsible for identifying the model as the Infante Baltasar Carlos, depicted here with the pomp of royalty and the insignia of his rank: sword, commander's baton, steel pectoral, plumed hat. According to Pacheco, this work is one of the first court portraits that Velázquez painted after his return from Italy. It was probably completed in March, 1631, a date that seems to be confirmed by an inscription on the painting—Ætatis AN. . MENS 4—which refers to the age of the prince at the time of the sitting; he was then one year and four months old. The traditionally held theory that the dwarf was Francisco Lezcano (better known as *El Niño de Vallecas* [see colorplate 25]), proposed by José Moreno Villa at a time when it was believed that the painting dated from 1634, can no longer be accepted, for Lezcano did not enter into the service of the Spanish court until 1634.

Velázquez's incomparable genius, not only as a portraitist but, specifically, as a painter of children, is already apparent in this painting. The movement of the child who is posing—or, more precisely, who can scarcely stay still without constantly fidgeting and changing his expression—and his impulsive nature make him a redoubtable model, indeed. Despite lingering traces of the stifling formality that characterized the Spanish court at the time, Velázquez managed here to capture the doll-like face of the young Baltasar Carlos, the intense gaze of his large dark eyes. In marked contrast to the prince is the dwarf-clown with his large head and undersized body, who holds a silver rattle in one hand and an apple in the other. Velázquez's portrayal of the dwarf indicates his ability to take a profound sympathetic interest in a creature who, though deformed by nature, will nevertheless become a man among men.

On a purely pictorial level, we can admire the magnificent harmony of the deep blacks, rich browns, golds, and especially the reds which set off the nuances of white in the apron of the dwarf and the plumes of the hat at the right.

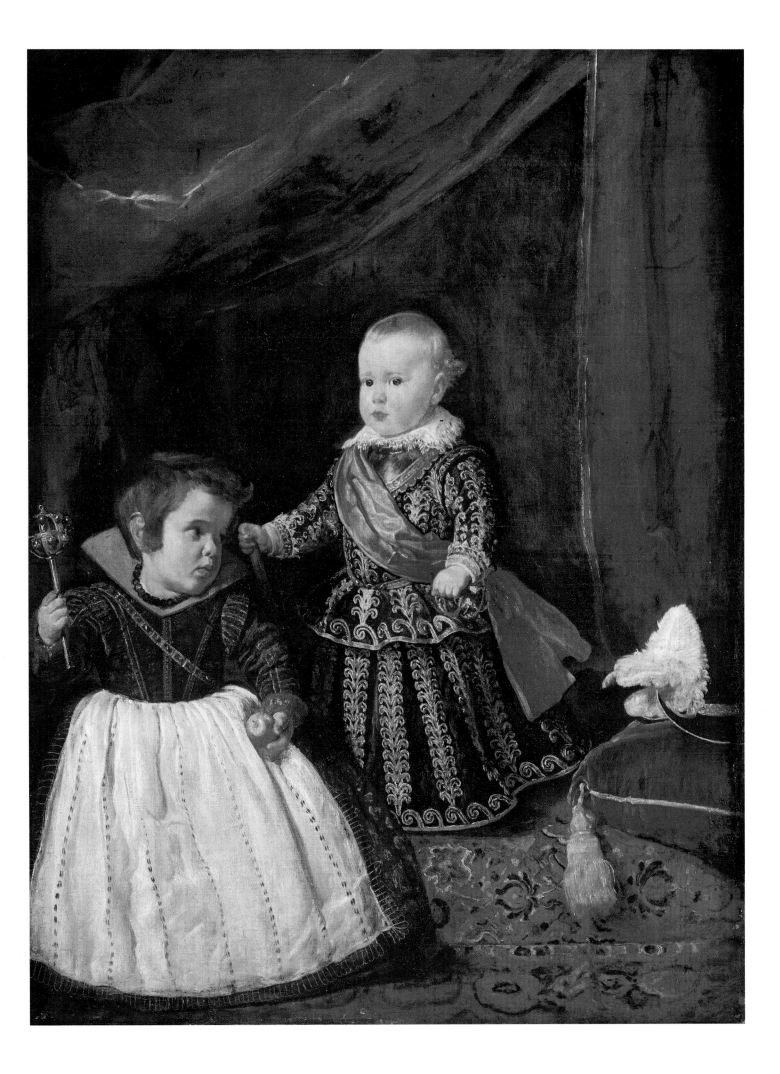

CHRIST ON THE CROSS
(CHRIST OF SAN PLÁCIDO)

c. 1630-32

Oil on canvas, 97 7/8 × 66 1/2"

Provenance: Sacristy of the Convent of Benedictine Nuns, Church of San Plácido, Madrid (until 1808); after some rather obscure transfers of ownership—according to López-Rey, it belonged to Manuel Godoy, at Boadilla del Monte, then to Godoy's wife, the Countess of Chinchón, in Paris(?)—and an attempted sale (Paris, 1826), it became the property of the duke of San Fernando (1829), who presented it to King Ferdinand VII of Spain; the Spanish monarch then gave it to the Prado museum; (since 1829) Museo del Prado, Madrid (no. 1167).

Various dates have been proposed for this painting: 1628 (Allende-Salazar); c. 1632 (Manuel Gómez-Moreno); c. 1631-32, after Velázquez's return from Italy (López-Rey); 1630 (Bardi). Other art historians have suggested dates as late as 1635. In any event, we feel fairly certain that it was executed about 1630-32, after the artist's trip to Italy.

In this interpretation of the Crucifixion, Christ's body is nailed to the Cross with four nails, with one foot beside—not overlapping—the other, in keeping with traditional iconography in Seville. A 1614 *Crucifixion* by Pacheco incorporates the same details. We should also mention the striking similarity between Velázquez's Christ and that of the renowned sculptor Juan Martínez Montañés (1568-1649). The trompe l'oeil effect of the wood of the Cross attests to Velázquez's attraction to the supernatural quality of contemporary Spanish polychromed sculpture: witness the coagulated blood dripping over the body of Christ and the Cross alike.

So perfectly proportioned is the body of this Christ that one might be tempted to call it "Apollonian" in concept, notwithstanding the fact that, as we have already seen, Velázquez did not strive particularly toward depiction of pure beauty or of subtle, arabesque-like forms. In this respect, he is opposed to the Florentine tradition. Here, however, the artist seems to have perceived the Son of God in a different light. Velázquez utilizes his extraordinary genius to challenge and even surpass reality, resulting in a kind of precursory Surrealism. But the inspired style and content of this painting are of such superior quality that we would be doing an injustice to Velázquez's memory to apply a label to his work that brings to mind the Christ of Salvador Dali. Dali's conventionalism could never be compared to the genius of Velázquez.

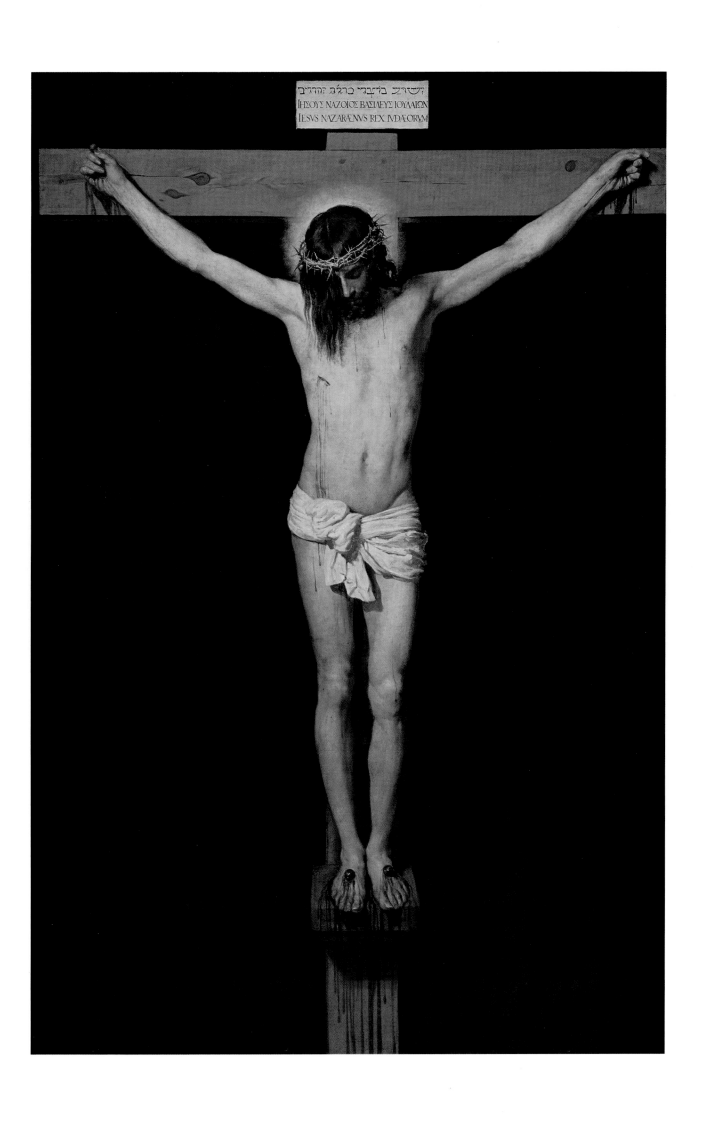

KING PHILIP IV IN A COSTUME EMBROIDERED WITH SILVER (THE SILVER PHILIP)

c. 1631–35

Oil on canvas, 76 7/8 × 43 1/4"

Provenance: Palacio Real del Buen Retiro, Madrid; presented by Joseph Bonaparte to General Desolles (January 4, 1810), who took the painting to France; after Desolles's death (1828), his daughter sold it to Woodburn William Beckford, who sold it to the dukes of Hamilton (1844–82); put up for sale (lot no. 1142) and purchased by the National Gallery, London, for the sum of 6,000 guineas (August 18, 1882); (since 1882) National Gallery, London (no. 1129).

Outstanding for the unrestrained, modern treatment of its subject, this portrait was executed after Velázquez's return from Italy, either about 1631–32 (López-Rey) or c. 1635 (Bardi). One of the artist's rare signatures may be discerned on the piece of paper held in the king's right hand: *Señor/Diego Velazus/Pintor de V. Maj.*

Notwithstanding the poet Antonio Machado y Ruiz's (1875–1939) description of the subject as dressed in black down to his feet, this painting is known in England as "The Silver Philip"!

Here we witness that prodigious technical skill that has motivated some critics to label Velázquez's style pre-Impressionism. The brushstrokes—fragmented and broken, lively and vibrant, impasto, fluid, transparent—are applied with astounding freedom. This painting is a far cry, indeed, from the official Renaissance portraits by Antonio Moro, Alonso Sánchez Coello, and Juan Pantoja de la Cruz, admirable in their own right. Their sitters were clothed in elaborate costumes of brocade, damask, or other rare fabrics splendidly decorated with gems, embroidery, passementerie, silver, or gold. The result was a polished, overmeticulous portrayal of wax-museum monarchs and nobility, stiffly decked out in their finery. Freeing himself from this kind of constraint, the court painter Velázquez demonstrates in this work his ability to execute an official portrait without bowing to suffocating conventions, formulas, or dictates. His approach proves that a royal portrait can depict the man as well as the king.

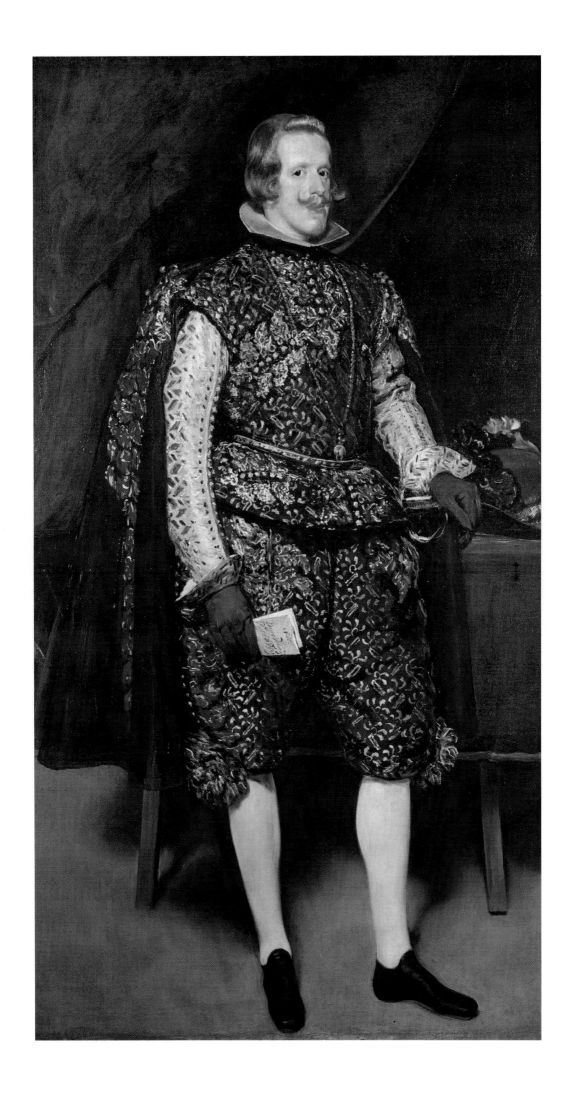

THE BUFFOON
PABLO DE VALLADOLID

c. 1624–33

Oil on canvas, 82 1/8 × 48 1/2"

Provenance: Palacio Real del Buen Retiro, Madrid (inventory of 1701); New Palacio Real, Madrid (inventories of 1772, 1794, 1814); Real Academia de Bellas Artes de San Fernando, Madrid (listed in 1816 as Portrait of a Magistrate*); (since 1827) Museo del Prado, Madrid (no. 1198). (The model was unknown at first, but was later identified by Pedro de Madrazo.)*

Bardi believes that this portrait, which is usually dated somewhere in the mid-1630s, was completed in 1632.

Pablo—or Pablito—de Valladolid entered the service of the Spanish court in 1632 and remained there until his death on December 2, 1648. The somewhat declamatory bearing of this striking figure makes him seem more an actor than a court jester. A remarkable similarity between Valladolid's face and that of Velázquez's *Democritus* (Musée des Beaux-Arts, Rouen) has often been noted.

This portrait provides yet another example of the modernity of the artist's style of painting. There is nothing extraneous here, no curtains, tables, or armchairs to distract the eye: the model is set, isolated, against a neutral background that focuses our attention all the more on his features. This treatment bears out Velázquez's concern for his subject above all else. Such an approach to portraiture brings to mind the work of Édouard Manet in the nineteenth century; Manet was frequently influenced by the Spanish masters. In addition to Manet's *The Tragic Actor*, there is the celebrated *Fifer* (Galerie du Jeu de Paume, Paris) that led Baudelaire to speak of its "nowhere" background, since there are no references of a picturesque or anecdotal nature that might otherwise divulge the painting's date. Likewise, Velázquez's buffoon seems virtually cut out from the background in bold relief, thereby lending the painting forceful vitality.

The dark tones of the clothing with their subtle reflections of light, which Velázquez excelled in rendering, later captivated Gustave Courbet, the chief exponent of the nineteenth-century French realist school, as well as Édouard Manet after him.

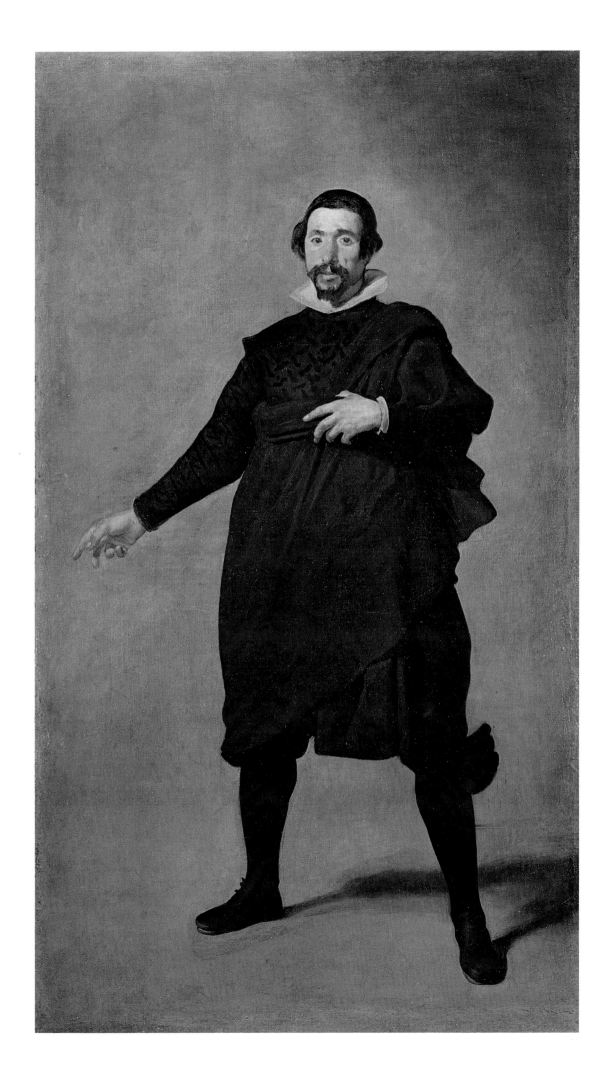

THE SURRENDER OF BREDA
("LAS LANZAS")

1634-35

Oil on canvas, 10' 1 1/8" × 12' 3/4"

Provenance: Salón de Reinos, Palacio Real del Buen Retiro, Madrid (April 28, 1635), and listed in the inventory of 1703; New Palacio Real, Madrid (inventories of 1772, 1794); (since 1819) Museo del Prado, Madrid (no. 1172).

Dating from 1634–35, this gigantic historical painting was commissioned from Velázquez to commemorate the tenth anniversary of Spain's conquest of the fortified city of Breda (Holland) by the Genoese commander of the Spanish troops, Ambrosio de Spínola (1569–1630), Marqués de los Balbases. The scene shows Justinus de Nassau (1559–1631), governor-general of the city, handing over the keys of his vanquished fortress to the victorious general on June 5, 1625.

Since Velázquez never visited Flanders, he had to research the geographical setting as well as document the details of the event itself. Art historians usually cite the following sources as some of Velázquez's possible influences: an engraving by Jacques Callot in the *Obsidio Bredana* by Hermannus Hugo (Antwerp, 1629), commissioned by the Infanta Isabella Clara Eugenia; the account contained in *Las Guerras de Flandes*; and undoubtedly various maps. Pieter Snayers's *Taking of Breda* (Museo del Prado) dates from 1650, fifteen years after Velázquez's version, and therefore could not have played a part in the latter's visualization of the event.

Many comparisons may be made and sources of inspiration suggested for the lances, the motif that made this painting world famous. In addition to Paolo Uccello's celebrated *Battle of San Romano* (Musée du Louvre), Piero della Francesca's battle scenes in the "Legend of the True Cross" fresco cycle (San Francesco, Arezzo), and the *Martyrdom of Saint Maurice* by El Greco (Monastery of El Escorial), many other artists have included lances in their works to give the impression of dense groups of combatants, or of entire armies engaged in battle or on the march.

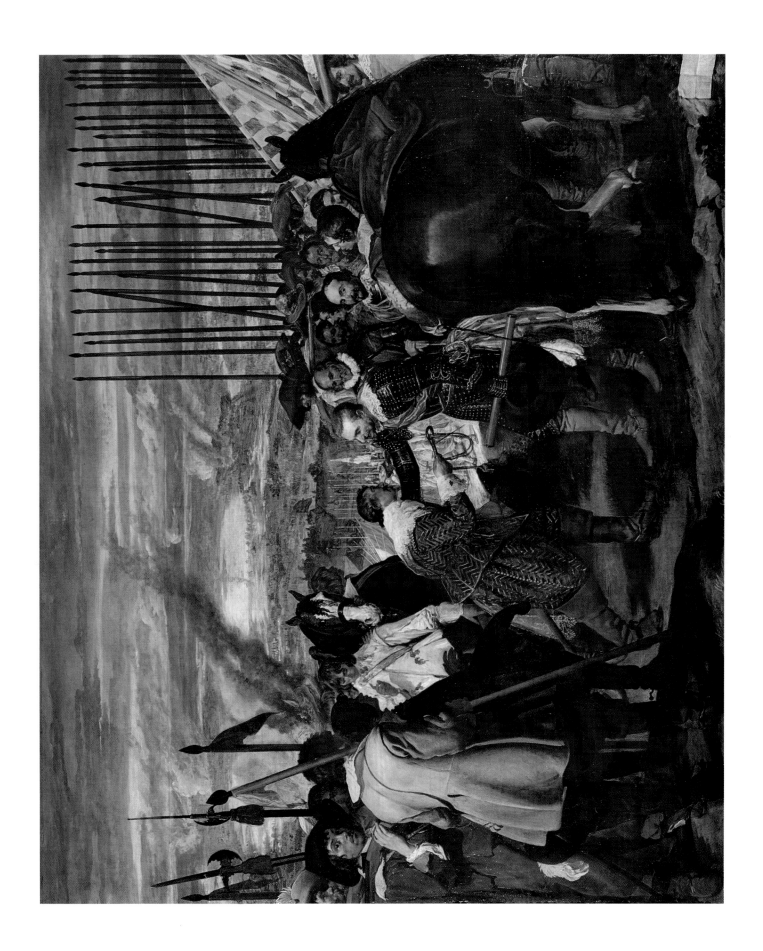

THE SURRENDER OF BREDA
("LAS LANZAS"), detail

Paul Jamot believes that the central group comprising the two commanders may have been inspired by Bernard Salomon's wood engraving of *The Encounter Between Abraham and Melchizedek* illustrating Claude Paradin's *Quadrins historiques de la Bible* (Lyons, 1553). In addition, it has been suggested that the group of Spanish soldiers at the right may have been patterned after El Greco's figures in the *Expolio* (Cathedral of Toledo).

According to Juan Allende-Salazar and Francisco Javier Sánchez Cantón, the two figures behind Spínola may be John of Nassau-Siegen and the Count of Feria. It is further believed that the figure standing near the horse at the extreme right, and wearing a large white-plumed hat, is Velázquez himself, and that the artist intended to inscribe his signature on the sheet of paper that he placed in the foreground.

Yet, aside from this admirable gallery of portraits—whether of notables or simply of ordinary models—it is the background landscape that attests to the unique talent of the artist.

The sheer immensity of the panoramic view; the planes, arranged according to harmonious studied rhythms, which delineate forms in space; the delicacy of color values to suggest the atmosphere; the light which plays in subtle reflections across the vast plain; the bluish tints in the distance; the limpidity of the partly cloudy sky—everything conspires to evoke our amazement before the boldness and refinement of the artist's brush.

The lances that fill the upper right section, as well as the halberds at the left, contribute to the order of the overall composition.

Can it be purely coincidental that in Eugène Delacroix's *Entrance of the Crusaders into Constantinople* (Musée du Louvre), the monumental canvas exhibited at the Salon of 1841, the treatment of the background is quite similar to that in *The Surrender of Breda*?

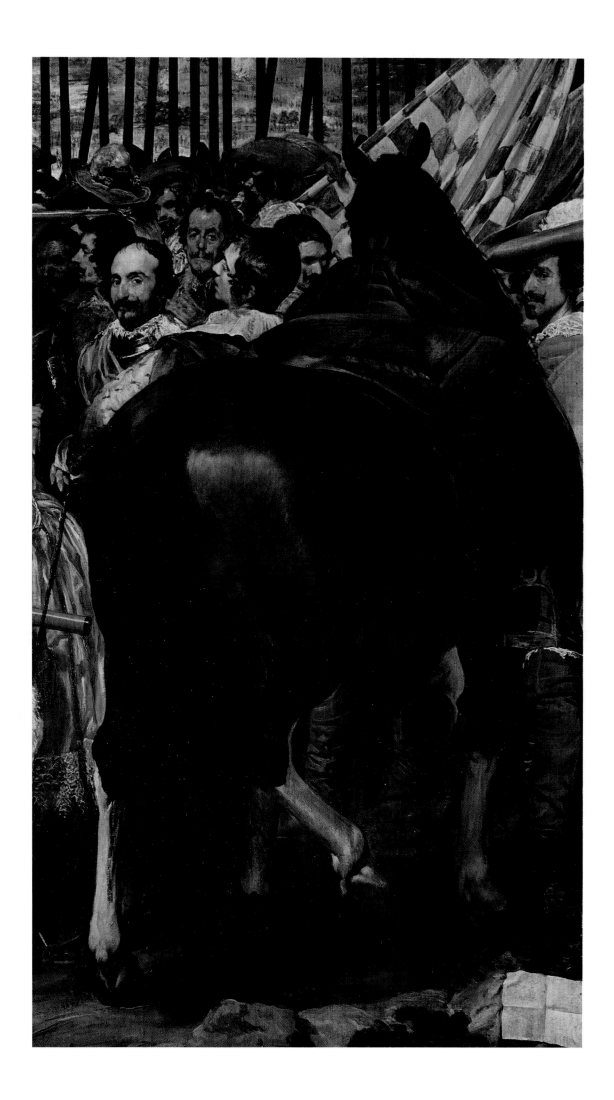

EQUESTRIAN PORTRAIT OF
THE COUNT-DUKE OF OLIVARES

c. 1634–35

Oil on canvas, 10' 3 1/2" × 7' 10 3/8"

Provenance: Count-Duke of Olivares, and his heirs; during the eighteenth century, owned by the Marqués de La Ensenada, whose collection was ordered sold in 1769 by King Charles III of Spain; bought by King Charles III for 12,000 reals, and placed in the New Palacio Real, Madrid (inventories of 1772, 1794, 1814); (since 1819) Museo del Prado, Madrid (no. 1181).

Don Gaspar de Guzmán, Count-Duke of Olivares and Duke of Sanlúcar la Mayor, was born on January 6, 1587, in Rome, and died on July 22, 1645, in the northern Spanish town of Toro. He was Philip IV's prime minister from the king's ascension to the throne in 1621 until 1643. A favorite of the king, among his numerous duties he was entrusted with the command of the Spanish cavalry. Spain's siege of the plaza of Fuenterrabía in the autumn of 1638, a victory due in large measure to the count-duke's tactical skill, is depicted in the background of this painting.

The lovely equestrian portrait by Velázquez—believed by most art historians to have been completed about 1634–35—was used by Jusepe Leonardo as a model for his *Taking of Brisach* (Museo del Prado), one of the series of historical works commissioned for the Salón de Reinos in the Palacio Real del Buen Retiro (it was there in April, 1635). An engraving of Velázquez's painting was later made by Goya.

Of the several copies of this work that are known to exist, the most famous, now in The Metropolitan Museum of Art in New York, is generally attributed to Juan Bautista del Mazo.

The plasticity of form of the equestrian group lends it an especially sculptural quality. With a remarkable skill, horse and rider alike seem almost modeled "in the round," an effect that makes the landscape appear that much lower down and farther away.

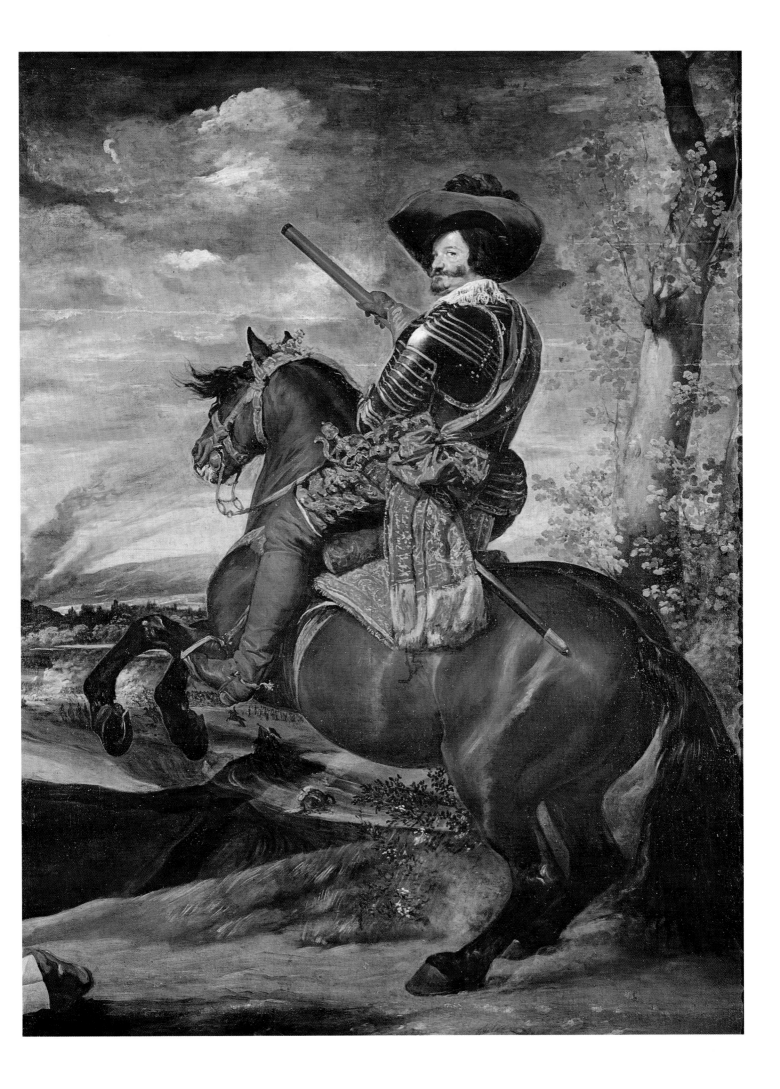

THE INFANTE BALTASAR CARLOS AS A HUNTER

1635-36

Oil on canvas, 75 1/4 × 40 5/8"

Provenance: Together with the portraits of King Philip IV as a Hunter *and* The Cardinal Infante Don Fernando as a Hunter, *one of the series of hunting portraits commissioned by Philip IV for his favorite hunting pavilion, the Torre de la Parada, in the park of El Pardo (inventory of 1701); probably transferred c. 1750 to the New Palacio Real, Madrid (inventories of 1772, 1794); (listed in the first catalogue, 1819), Museo del Prado, Madrid (no. 1189).*

An inscription giving the model's age—ANNO ÆTATIS SVAE.VI—enables us to date this portrait accurately. Since the prince was born in the autumn of 1629, the painting was completed in 1635 or, at the very latest, in the first part of 1636.

The canvas was cut off at the right side, so that only part of the second dog is left. Certain copies, all from the artist's studio, lead us to believe that the original portrait may have included as many as three dogs.

There is another series of copies inspired, more or less, by this painting that depict Prince Baltasar Carlos dressed in armor, rifle in hand. In one of these canvases he wears a plumed hat; in others he is shown bareheaded. Velázquez's forte was, unquestionably, portraits of children. With his unique talents, he evokes the freshness and pertinence of a child's thoughts, of minds just awakening to and discovering life, meeting injustice with youthful indignation, but ever sensitive to the attention and affection that is showered upon them. With the possible exception of the Impressionist painter Auguste Renoir, we know of no other artist able to portray children with the same degree of fervor and perceptiveness in which Velázquez excelled.

Finally, we again note in this canvas that the artist has painted a wonderful landscape in the background, the bluish tones enveloping the distant mountains and sky in a delicate and airy mist.

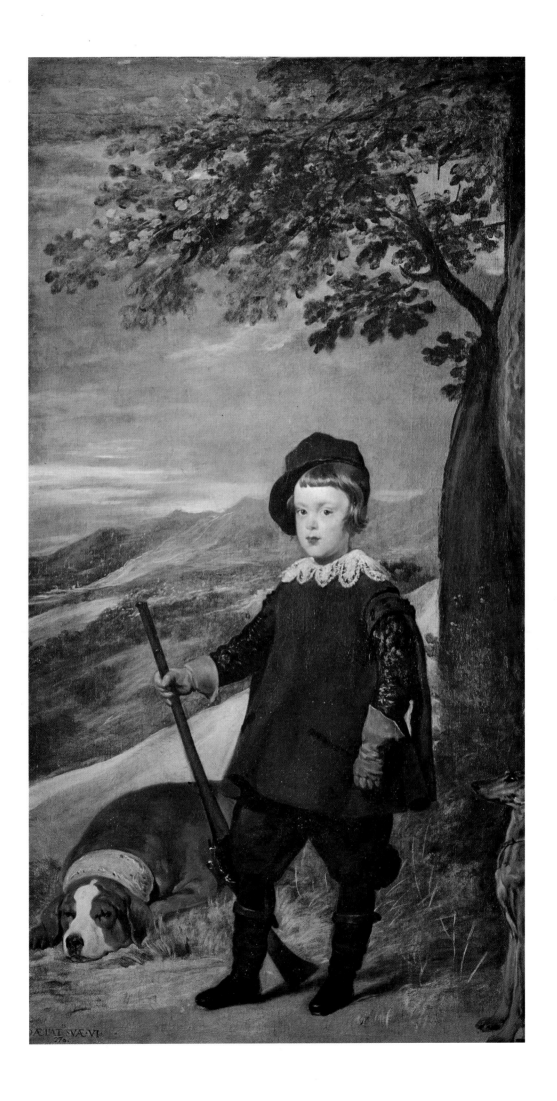

SAINT ANTHONY ABBOT
AND SAINT PAUL THE HERMIT

c. 1634–60

Oil on canvas, 8' 5 7/8" × 6' 2"

Provenance: Probably executed for the Hermitage of St. Paul, on the grounds of the Palacio Real del Buen Retiro, Madrid; subsequently discovered at the Hermitage of St. Anthony, also part of the Buen Retiro palace (inventory of 1701); New Palacio Real, Madrid (inventories of 1772, 1794, 1814); (since 1819) Museo del Prado, Madrid (no. 1169).

The date of this painting has been a topic of controversy among art historians. Allende-Salazar, López-Rey, and a few others suggest that it was completed c. 1634; Bardi proposes a date near 1642, and still others believe it to be even later. If, for instance, Beruete's proposed date of 1660 is accurate, then this would be Velázquez's last painting.

A careful examination of the upper portion of the work reveals that the canvas was originally arched. In terms of iconography, the artist has incorporated into the scene a number of references to religious episodes. In the foreground the principal event unfolds: the two saints are to be fed by a crow flying toward them, holding what appears to be a loaf of bread(?) in its beak. Behind the saints, beneath a fault in the rock, Saint Anthony is seen knocking at the hermit's cave. At the lower left, two lions are digging the grave of Saint Paul, whose mortal remains are watched over by his companion, Saint Anthony, kneeling beside him. In the background, Velázquez has depicted the meeting between Saint Anthony and the centaur.

The sources of the iconography support various hypotheses put forward by one art historian or another. A fresco by Pinturicchio in the Borgia apartments in the Vatican deals with the same theme, as does a famous woodcut of 1504 by Albrecht Dürer. The German master's version, in turn, was the source for Girolamo Savoldo's painting of the two saints (Gallerie dell'Accademia, Venice). In addition, one could compare Velázquez's landscape with that in Joachim Patinir's *Saint Jerome in Penitence* (Museo del Prado).

Once again, the artist reveals his deep love for nature in his treatment of the landscape, which—despite the comparisons mentioned above—is most reminiscent of the granite rocks of Guadarrama, with which, as Bardi points out, Velázquez was quite familiar.

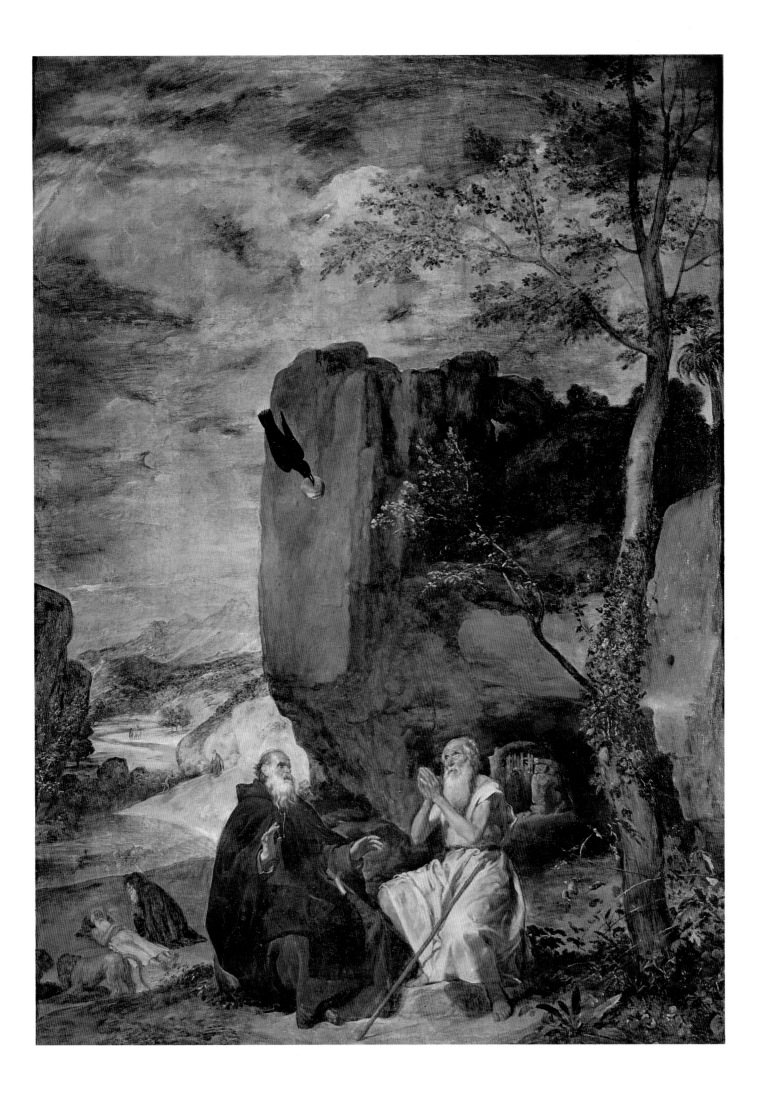

AESOP

c. 1639–42

Oil on canvas, 70 1/2 × 37"

Provenance: With its companion piece, Menippus, *commissioned for the Torre de la Parada, part of El Pardo palace, and probably positioned on tall, narrow walls between the windows (inventory of 1703); Palacio Real del Buen Retiro, Madrid (from 1714 to c. 1734); New Palacio Real, Madrid (inventories of 1772, 1794); (since 1819) Museo del Prado, Madrid (no. 1206).*

Together with its pendant, *Menippus*, this painting was completed sometime between 1639 and 1642.

The Flemish painter Peter Paul Rubens was sent by his patron, Vincenzo Gonzaga, Duke of Mantua, on a mission to King Philip III in 1603, and while on that first trip to Spain he painted *Democritus Laughing* and *Heraclitus Weeping*. Both were originally hung in the Torre de la Parada, the royal hunting lodge, but were subsequently transferred to the Prado. The commonplace picturesqueness of these two works, suffused with that earthy, vigorous quality typical of Flemish art, undoubtedly influenced Velázquez as he set out to paint his *Aesop* and his *Menippus*. But far from imitating Rubens's models, the artist chose two fallen *Hidalgos* to portray the famous Greek philosophers.

Scrutinizing the observer with uncompromising candor, Aesop, the great satirist—whose fables were La Fontaine's key source of inspiration—is depicted here with an ironic expression, indicating an air of disillusionment toward mankind, albeit not without indulgence.

The bold technique of applying thick impasto in broad sweeping brushstrokes heralds the style of Édouard Manet. Browns dominate the overall color scheme, thereby accentuating the straightforward simplicity of the subject.

Instead of portraying an ancient Greek poet as a figure from antiquity (as the seventeenth-century French artists Nicolas Poussin and Charles Le Brun would do), Velázquez once again paints his subject as a man of his own time, drawing his models directly from the common people much as his contemporary Cervantes did in his *Novelas ejemplares* (especially *Rinconete y Cortadillo*).

Thus, one of the most striking characteristics of Velázquez's work is that his models, although in reality belonging to his own era, manage to transcend it, existing outside of any time framework; they would have been just as appropriate several centuries before, as they would be in advance of their time.

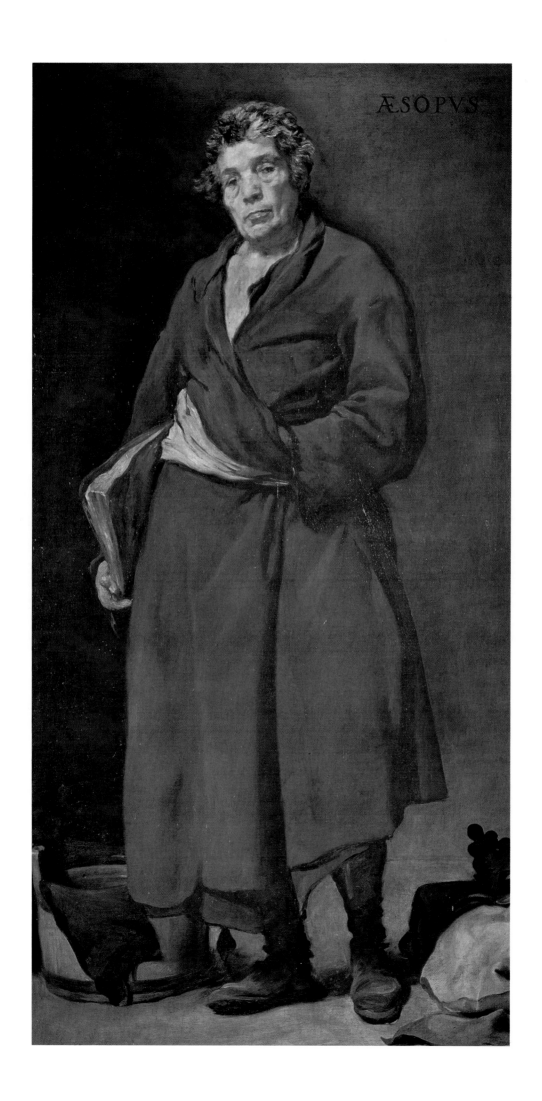

THE DWARF FRANCISCO LEZCANO
(EL NIÑO DE VALLECAS)

c. 1637-45

Oil on canvas, 42 1/8 × 32 3/4"

Provenance: El Pardo; Palacio Real del Buen Retiro, Madrid (since 1714; perhaps one of the paintings of dwarfs in the Torre de la Parada in 1700); New Palacio Real, Madrid (inventories of 1772, 1794); (since 1819) Museo del Prado, Madrid (no. 1204).

The dwarf Francisco Lezcano was also known as *El Niño de Vallecas, Lezcanillo,* and the *Enano viscaíno.* Lezcano entered the service of Prince Baltasar Carlos in 1634. Since he was part of the retinue that accompanied the prince to Saragossa in 1644, López-Rey suggests that it was in the years 1643-45 that the portrait was completed. Bardi, however, has proposed an earlier date, about 1637.

Francisco Lezcano was away from court from 1645 until late in 1648. He died one year after his return, in October, 1649.

The portrait of this unfortunate, mentally retarded dwarf, deformed, hydrocephalic, and seemingly afflicted with facial paralysis as well, is, indeed, a tragic sight to behold. The Spanish predilection for the monstrous and for deformed creatures is well-known in artists ranging from Ribera (*Boy with a Clubfoot*; Musée du Louvre) to the monsters of Goya or Picasso. The guiding principle of these painters was unswerving devotion to the truth, without any indulgence for the physical appearance of the model; the subject, whether the most repulsive creature or the most perfect beauty, is rendered with ruthless fidelity. As a result, over and above the brilliance of their profound psychological insight, there emerges in these paintings a certain poignant feeling for humanity.

Velázquez's approach always manages to establish contact between the artist and model, as well as between the model and us, the observers. His sober color harmonies contribute toward this effect, and even enhance it.

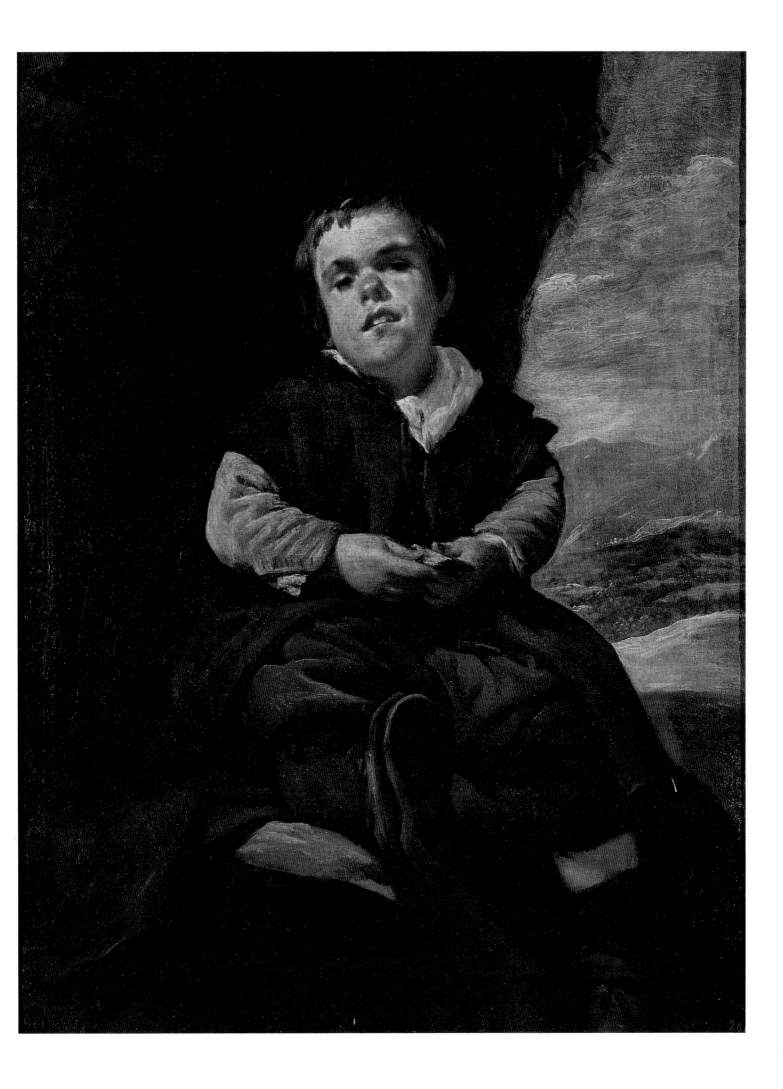

THE CORONATION OF THE VIRGIN

c. 1641–44

Oil on canvas, 69 1/4 × 48 7/8"

Provenance: Painted for the Oratory of Queen Isabella (first wife of Philip IV), El Alcázar, Madrid; later placed in the antechamber of the New Palacio Real, Madrid (certain inventories list it as a work by Alonso Cano); (since 1819) Museo del Prado, Madrid (no. 1168).

This work dates from 1644, according to López-Rey; others place it somewhat earlier, about 1641–42. The latter opinion stems from the fact that this painting was clearly used as a model for Jusepe Martínez's version, completed in 1644, for the Cathedral of Saragossa.

With regard to the overall compositional plan, it has been suggested that Velázquez may have been influenced by a woodcut of 1509 by Dürer of *The Assumption*, as well as by similar subjects painted by El Greco, which seems entirely likely.

The Virgin may well have been modeled after Montañes's *Virgin* (1631) in the Cathedral of Seville.

Although the general arrangement of the composition is according to tradition and to specific works by El Greco, the colors and forms of the figures bear no resemblance whatsoever to those of Velázquez's great predecessor. Indeed, with El Greco bodies were bent and elongated according to a very refined aesthetic of arabesques, and exaggerated to the highest point of their mystical intensity, an approach that led Jean Cassou to remark, in a flash of wit, that El Greco did not paint that way because he was astigmatic; he became astigmatic because he painted that way!

In Velázquez's version of the theme, however, the figures are treated soberly, their bodies and faces so very realistic that the nineteenth-century art critic Anna B. Jameson (*Legends of the Madonna*, London, 1852) took exception to the baldness of God the Father! In contrast to the play of blues, whites, and golds that was El Greco's specialty, Velázquez employs a very different palette, with reddish and purplish hues predominating. These set off to advantage the blue drapery of the Virgin.

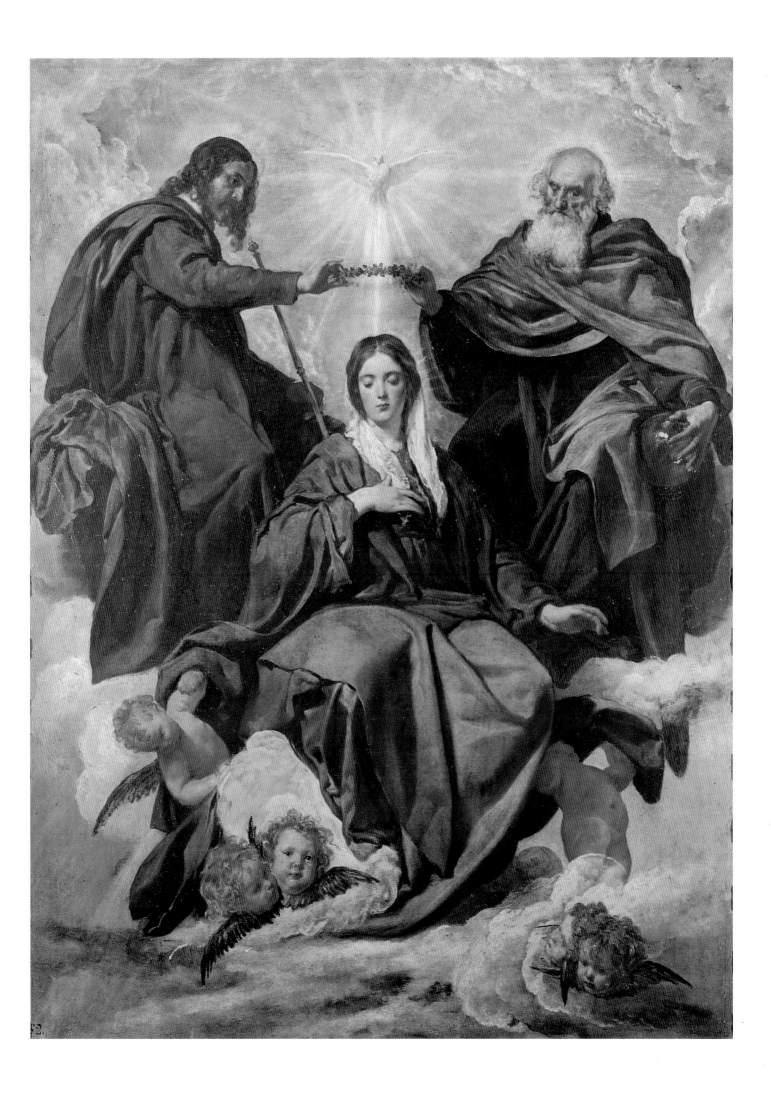

JUAN DE PAREJA

c. 1650

Oil on canvas, 30 × 25 1/4"

Provenance: In the possession of a Roman cardinal, c. 1750; Baranello Collection, Naples; Collection of Sir William Hamilton, British Envoy to Naples (c. 1798); Sir William Hamilton sale, London, March 27, 1801 (sold for 39 guineas); (from 1811) Collection of the Earl of Radnor, Longford Castle, near Salisbury, England; purchased May, 1971, by The Metropolitan Museum of Art, New York.

Juan de Pareja was the mulatto servant, friend, and pupil of Velázquez who accompanied him to Italy; consequently, this work is sometimes called *The Slave of Velázquez*. The portrait was completed in Rome in February (?) of 1650, and exhibited the following month in the Pantheon, concurrent with the artist's success in the Italian capital.

Evidently of Moorish ancestry, Juan de Pareja was born in Seville about 1610 and died in Madrid in 1670. His ambition to be a painter brought him from Seville to Madrid, where he became Velázquez's assistant; he went along in that capacity during the master's second trip to Italy (1648–51).

This half-length portrait shows the model turned three-quarters to the right. Executed with remarkable freedom of technique, this work should be considered separately from Velázquez's great official portraits, but nevertheless as among the most outstanding paintings executed by the master, especially during the second half of his career. The brushstrokes are applied with exceptional verve; the face is modeled with profound expressivity.

When the portrait was sold in London in 1971 to New York's Metropolitan Museum of Art for $5.5 million, the price was deemed fabulous by current market standards.

Several copies of the work are known to exist.

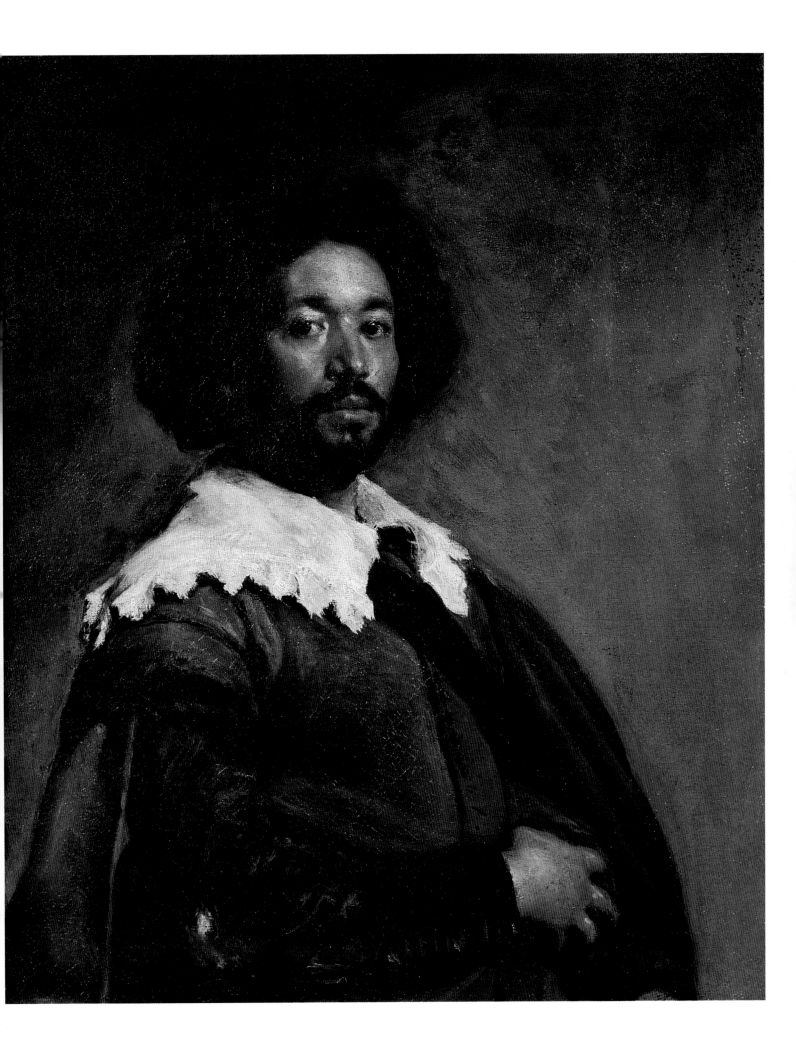

POPE INNOCENT X

1650

Oil on canvas, 55 1/8 × 47 1/4"

Inscribed on the piece of paper held by the pontiff:
Alla San^ta di N^ro Sig^re / Innocencio X^o/ Per / Diego de Silva/ Velázquez
dela Ca-mera di S. M^ta Catt^co/
Underneath, there are traces of additional writing and the date 1650.

*Provenance: Princes Doria-Pamphili, Rome; Galleria Doria-Pamphili, Rome
(no. 118).*

Pope Innocent X was born in 1576 and died in 1655.

Velázquez painted this work in Rome, probably in the autumn of 1650. It is said that the pope was so delighted with the portrait that he exclaimed, "All too truthful!" and sent a substantial sum of money to the artist which Velázquez, as an envoy and servant of the king, felt it necessary to decline. However, Velázquez did accept a gold chain and papal medallion, which are mentioned on the artist's tombstone.

A comparison of this masterpiece with Titian's *Pope Paul III and His Grandsons, Alessandro Cardinal Farnese and Ottavio Farnese* (Gallerie Nazionali di Capodimonte, Naples) is especially significant. Velázquez's use of color and his sensitive touch call to mind the Venetian painting technique that is more specifically characterized as "Titianesque."

Lionello Venturi once wrote that a portrait is either poetry or history. A Velázquez portrait is both at the same time, for the artist uses his initial visual impression to create a realistically modeled likeness of the sitter's face on the canvas. In this manner, all the humanity and truth of the subject are revealed. Indeed, Velázquez breathed new life into the art of portraiture in Spain, which, prior to him, was becoming increasingly sterile.

Here, the artist exploits the pope's ruddy, rather unattractive face and his crafty expression solely for artistic ends, but in the process of this "transfiguration" he brings out the character of the subject and his benevolence. Now the psychological aspects of pictorial representation must not make us overlook the plastic qualities of such a painting. In this case, the reds—one of the most difficult colors to use in painting without vulgarity or gaudy clashes—are combined, shaded, and built up into a rarely equaled color harmony. The resulting effect is one of density, richness, and sumptuousness, as well as extreme refinement and restraint—despite the model's apparent coarseness—which makes this portrait one of the most dazzling works of art of Spain's Golden Age.

There are several copies of this celebrated masterpiece.

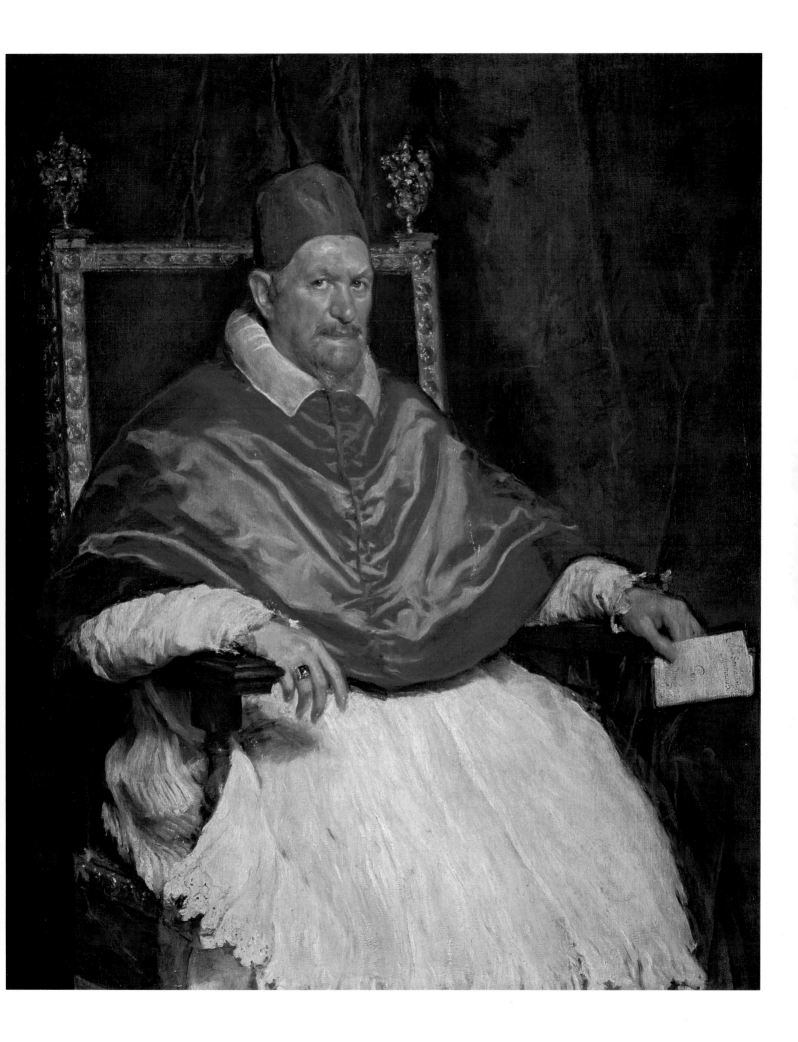

VIEW OF THE GARDENS OF THE VILLA MEDICI, ROME: THE LOGGIA OF THE GROTTO

c. 1650

Oil on canvas, 18 7/8 × 16 1/2"

Provenance: El Alcázar, Madrid (inventories of 1666, 1686); Palacio Real del Buen Retiro, Madrid (inventory of 1772); (since 1819) Museo del Prado, Madrid (no. 1210).

Most art historians are divided as to the dates of this small painting and its pendant (see colorplate 30). Some, including López-Rey, believe they were completed in 1630, during the artist's first trip to Italy. Others, including Bardi and myself, prefer 1650, at the time of Velázquez's second Italian trip. With certainty, champions of the earlier date cite evidence supporting Palomino, to the effect that Velázquez had been granted permission to stay at the Villa Medici through a request (dated April 20, 1630) made to the Secretary of State, A. Cioli, by the Tuscan Minister to Rome, Francesco Niccolini: ". . . The Count of Monterei has requested that lodgings be made available in the garden of the Trinità dei Monti to a newly arrived painter in the service of the king, who wishes to remain the entire summer; according to what I have been told, he is an excellent painter of portraits from life." It should be added, however, that Palomino does not mention either of these two landscapes as among those brought back to Spain by Velázquez after his first Italian sojourn.

Bardi notes that Velázquez was particularly attracted to the Palladian motif, rare in Spain, of an arch resting on an architrave supported by columns. The architecture that Velázquez depicts here, which still exists today, virtually intact, is attributed to Bartolommeo Ammanati: the pilasters topped with Ionic capitals are a typically Mannerist convention. Decorating a niche to the right, we see a powerful statue of the Niobids (the children of Niobe), a popular mythological theme.

This work by Velázquez, unquestionably a direct precursor of the Italian and Provençal landscapes of Hubert Robert and Fragonard, as well as of the views of Italy painted by Corot, is invested with a kind of classical realism that is not without emotional impact.

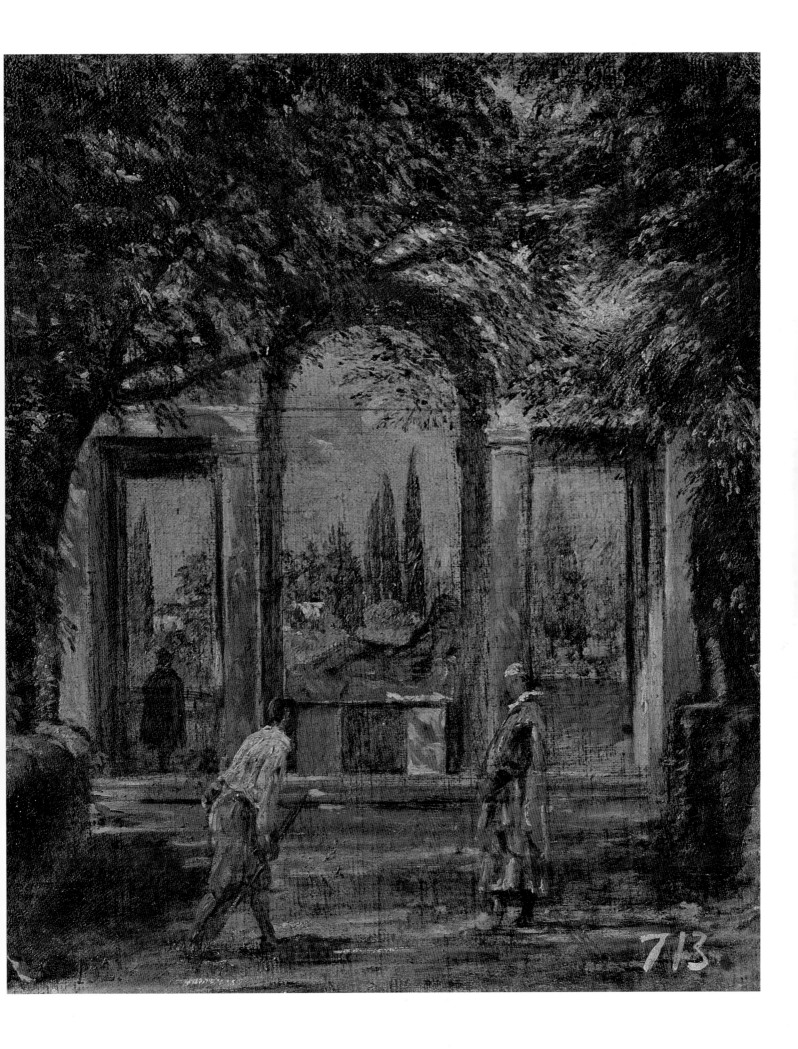

713

VIEW OF THE GARDENS OF THE VILLA MEDICI, ROME: THE PAVILION OF ARIADNE

c. 1650

Oil on canvas, 17 3/8 × 15"

Provenance: El Alcázar, Madrid (inventories of 1666, 1686); Palacio Real del Buen Retiro, Madrid (inventory of 1772); (since 1819) Museo del Prado, Madrid (no. 1211).

This is the companion piece to the painting reproduced in the preceding color-plate. The pavilion depicted in the painting, which took its name from a statue of Ariadne that once stood in the center—the statue was taken to Florence and replaced by a copy of Praxiteles' *Aphrodite of Cnidus*—was also known as the "Loggia of Cleopatra." No one has as yet provided a plausible interpretation of the actions of the two figures in the foreground.

If we compare *The Pavilion of Ariadne* with the preceding canvas, what strikes us particularly about this painting is the combination of patches of vibrantly reflected light and of transparent shadow that pervades the entire composition, in the landscape elements and architectural details as well as in the figures. Velázquez's private vision captures with a surprising modernity of style the fleeting movement of the reflections, a technique in which Monet, Sisley, and Pissarro would excel, much later, in the nineteenth century. In this connection, the painting can be said to truly prefigure Impressionism.

We can readily see that Velázquez, like all artists of his time, did not actually execute this landscape out-of-doors, directly from nature. However, he was one of the first artists of his day to convey a feeling of the outdoors through a highly personal and very modern painting style. To be sure, Velázquez shared the seventeenth-century predilection for relatively somber color which the Impressionists would later banish from their palettes, preferring instead the pure, clear color of reflected light. Yet, one can safely say that Velázquez was able to render in his studio a sensation of the outdoors that equaled what Gustave Courbet and Corot would later achieve directly from life. Thus each of these artists, as well as Velázquez—though their careers were separated by two centuries—must still be considered only forerunners of the true Impressionist vision.

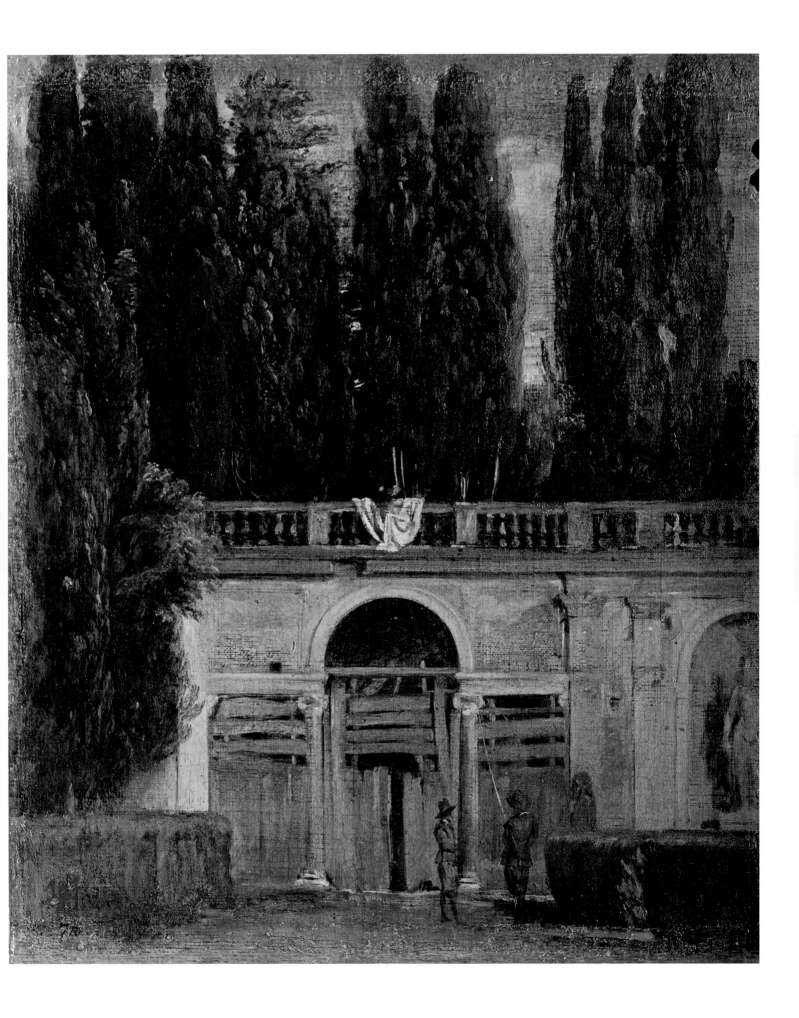

QUEEN MARIANA

c. 1652–53

Oil on canvas, 92 1/4 × 51 5/8"

Provenance: (until 1845) Monastery of El Escorial (inventories of 1700, 1746, 1771, 1794); Museo del Prado, Madrid (no. 1191).

Mariana was born December 21, 1634, and died May 16, 1696. She was the daughter of Emperor Ferdinand III and the Infanta María, the sister of King Philip IV. On October 7, 1649, when she was barely fifteen, Mariana married Philip IV—her uncle—who was then the widower of Queen Isabella of Bourbon.

Art historians for the most part agree that this portrait was completed in 1652 or, at the very latest, early in 1653. It is known that a studio copy of the work, which was transferred from Schönbrunn Palace to the Kunsthistorisches Museum in Vienna, had been sent to Archduke Leopold Wilhelm on February 23, 1653; thus the original had to have been finished prior to this date.

Regarded as the companion piece to *Philip IV in Armor*, this work shares its history as well as its location in the Prado museum.

A slightly smaller portrait of Mariana (measuring 82 1/4 × 49 1/4") was listed in the collections of El Alcázar in Madrid in 1734, and then in the Prado. As a result of a 1941 exchange between France and Spain, this painting is now owned by the Louvre. Several art experts are certain that the work is an original Velázquez; Sánchez Cantón even believes that this particular version is the one painted from life in 1652. However, Allende-Salazar, López-Rey, and other scholars consider it instead a studio endeavor in which Velázquez himself perhaps participated. In any case, it would appear that the version in the Prado (reproduced here) is the commonly agreed-upon original.

The color scheme of reds, blacks, whites, and grays, highlighted with gold, is of an extremely subtle delicacy. Our attention is especially drawn to the red ribbon near the left hand, which brings out the blacks and grays of the peplum of the gown, just as the golden jewelry accents the whites, grays, and blacks of the bodice. Once again, the portrait's unrestrained style brings to mind the art of Renoir.

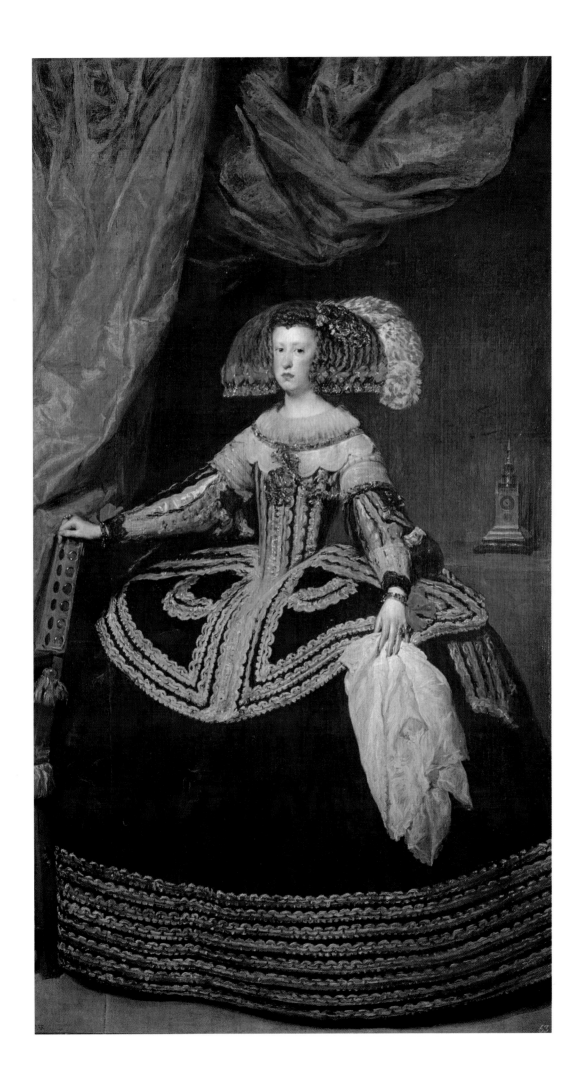

THE INFANTA MARÍA TERESA

c. 1652

Oil on canvas, 50 3/8 × 38 5/8"

Provenance: Presented by King Philip IV as a gift to the Hapsburg royal court; received by Emperor Ferdinand III in Vienna, February 22, 1653; (listed 1824) Kunsthistorisches Museum, Vienna (no. 353).

This painting—also called *Portrait with the Two Watches*, because of the time-pieces resting on the peplum of the young princess's dress—was probably painted in 1652, or, in any case, before February, 1653, when it was sent by King Philip IV as a gift to the Hapsburg court. The Infanta María Teresa, the daughter of Philip IV and Queen Isabella, was born on September 20, 1638; if 1652 is accepted as the accurate date of execution of the painting, then she would have been fourteen years old at the time of the sitting. The Infanta married King Louis XIV of France on June 9, 1660, and died on July 30, 1683.

Unfortunately, this work has suffered extensive damage over the years: that it was badly restored is especially apparent in the face, particularly the mouth and eyes. It seems equally probable that the canvas was originally larger, and was cut down to its present size. The princess undoubtedly must have been portrayed full-length originally, rather like the copy in the Museum of Fine Arts, Boston (once believed to be the work of Velázquez himself, but no longer an accepted attribution today). There is one other painting of the same subject in the Louvre, also considered a studio work, but it is actually a half-length version of the portrait.

In the Vienna canvas reproduced here one marvels again at the highly refined coloring of the dress and jewels. The nuances of color are delicately varied, and the brushstrokes bring out the highlights and luminous reflections that make the fabrics and objects shimmer with a life of their own. In Velázquez's work even the shadows are transparent, not opaque.

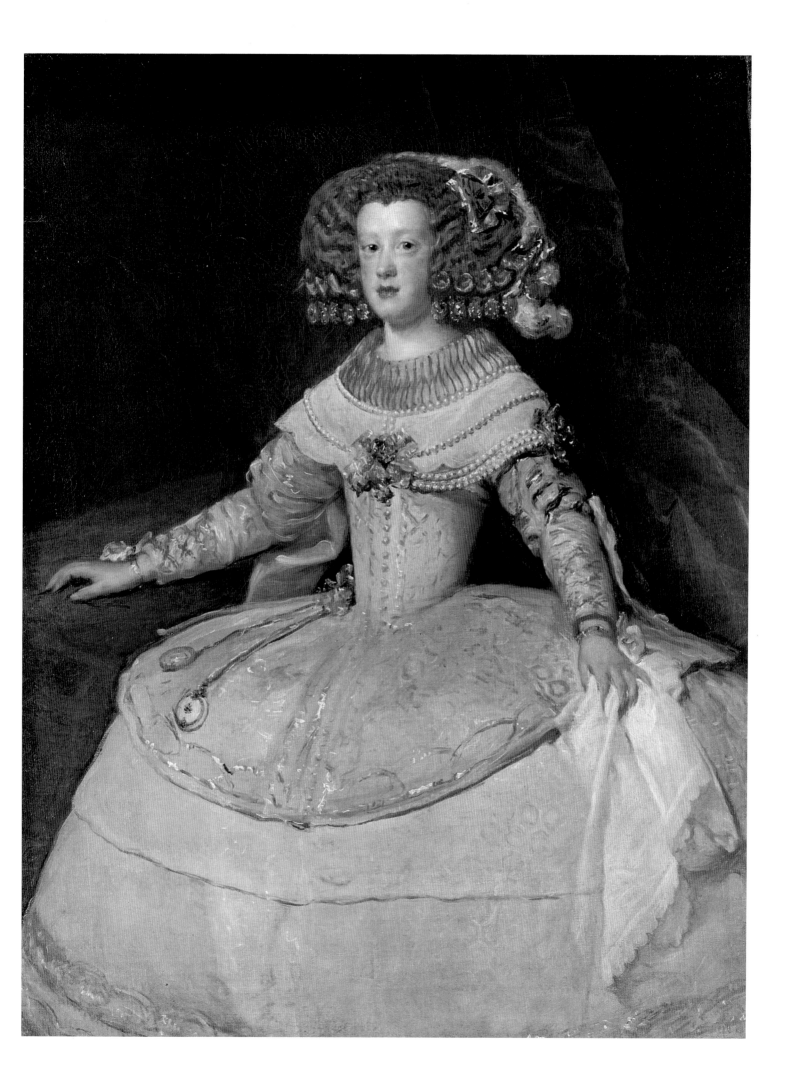

THE TOILET OF VENUS
(THE ROKEBY VENUS)

c. 1649–50

Oil on canvas, 48 1/4 × 69 3/4"

Provenance: Don Gaspar Méndez de Haro y Guzman, Marqués del Carpio y de Eliche (a relative of the Count-Duke of Olivares), listed in an inventory in Madrid, June 1, 1651; still in his possession in 1682 in Rome, then in 1686 in Naples; passed to his daughter, wife of the tenth duke of Alba, 1687; remained in the Alba Collection until 1802; sold by order of King Charles IV to Don Manuel Godoy, Príncipe de la Paz (until after October, 1808); Buchanan Collection, London (1813); J. B. S. Morritt, Rokeby Hall, Yorkshire, England; sold to Thos. Agnew and Son gallery by H. E. Morritt, London (1905); sold and presented (1906) to the National Gallery, London (no. 2057).

Most art historians today agree that this work was completed in Rome sometime during the artist's second sojourn in Italy—that is, between July, 1649, and November, 1650, with preference given to the later date.

Goya's *Maja Desnuda* (Museo del Prado) and Velázquez's *Toilet of Venus* are the only Spanish old master paintings of female nudes presently known to exist. However, according to inventories made during Velázquez's lifetime, it is presumed that the artist painted at least two other female nudes, in all likelihood also representing Venus.

A good many questions concerning *The Toilet of Venus* have been raised by art historians, whether Velázquez specialists or not. Why is Venus seen from behind? Why does the mirror reflect only the face of the model? Is this simple modesty? Or fear, on the part of the artist, of excommunication by the Church?

In any event, the mirror is an important motif in the paintings of Velázquez, as it was in the work of contemporary Dutch painters. In addition to the admirable study of the nude form which captures our attention, the mirror gives the painting a second center of interest in the face of the model, which is real and yet unreal in the nature of its own reflection so that it becomes a pretext for our imagination and our dreams.

Despite the beauty of the realistic modeling of the body, it is nevertheless stylized into a somewhat "guitar-shaped" form (as noted by Lafuente Ferrari) that may have inspired the stylized forms of the odalisques of Ingres almost two hundred years later. It has been suggested that Velázquez may have been influenced by certain sculptures from antiquity, by the female nudes in Venetian painting by Titian and Tintoretto, and perhaps by the work of Rubens, whose *Feast of Venus* (Kunsthistorisches Museum, Vienna) would have served as an ideal model for the Spanish master.

The blue-gray drapery on which the young woman reclines sets off to advantage the nuances of the flesh tones. These, in turn, register the play of reflections over the supple and voluptuous body, which is graced with an unsurpassed poetry.

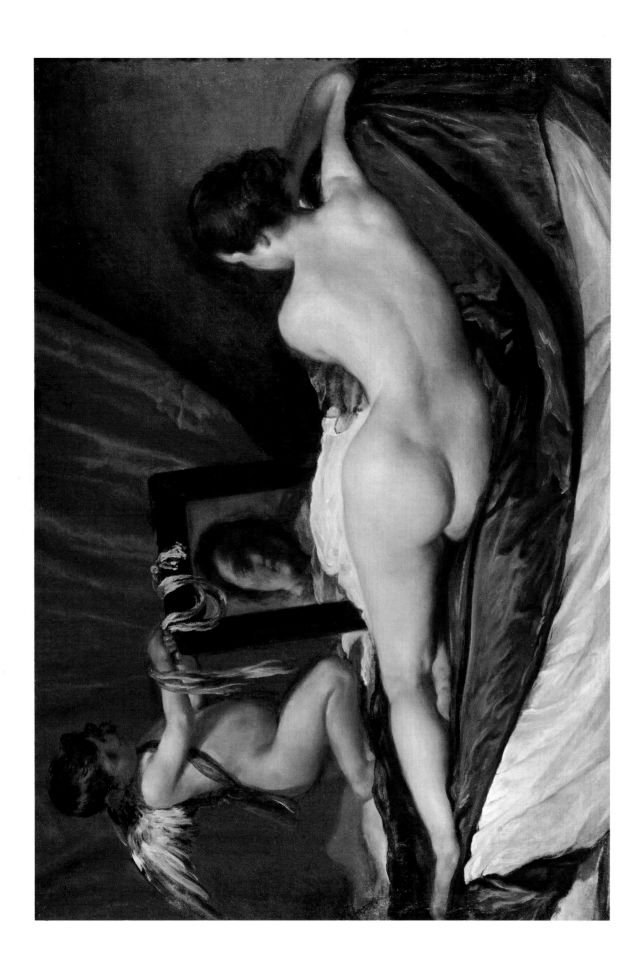

THE INFANTA MARGARITA

c. 1653–54

Oil on canvas, 50 3/8 × 39 3/8"

Provenance: Kunsthistorisches Museum, Vienna (no. 321).

Although the catalogue of the imperial gallery does not list this portrait until after 1816, it is still believed that the painting was presented by Philip IV to the Austrian royal court of the Hapsburgs.

The Infanta Margarita, born on July 12, 1651, was the daughter of Philip IV and Queen Mariana. She married Emperor Leopold I of Germany on December 12, 1666, and died on March 12, 1673. Since it is generally believed that this is the first of several portraits of the Infanta that Velázquez painted, and that she was approximately three years old at the time, the work has been dated 1654 or, at the earliest, 1653.

Despite the formalities of the Spanish court that dictated that farthingales hold supple waists in rigid submission, and that royal children be outfitted with showy costumes, Velázquez was able to penetrate the intimate and fragile lives of his young sitters—he conveys their awkwardness and restraint, and even a hint of the spirited outbursts that would follow once the sitting was over. It is in his ability to capture, during such changeable and practically intangible episodes, the instantaneousness of a fleeting expression or of a furtive glance that truly reveals the character of the young model—not what comes across in a pose, but how the child really is—that Velázquez demonstrates his extraordinary gift for ultrasensitive perception. Here, the artist has placed his model next to a bouquet of flowers resting on a table: the vibrant, "painterly" quality of the brushstrokes, the paint applied in subtly shaded reflections, brings to mind Renoir's portraits of children. The artistic and stylistic kinship that exists between these two artists is felt especially in the delicacy of color in the vase of flowers and is echoed in the Infanta's dress, the carpet, and the fabric covering the table.

A slightly different version of this work, formerly in the collection of the dukes of Alba and now in the Colección de la Casa de Alba, Madrid, is probably a copy executed by Juan Bautista del Mazo.

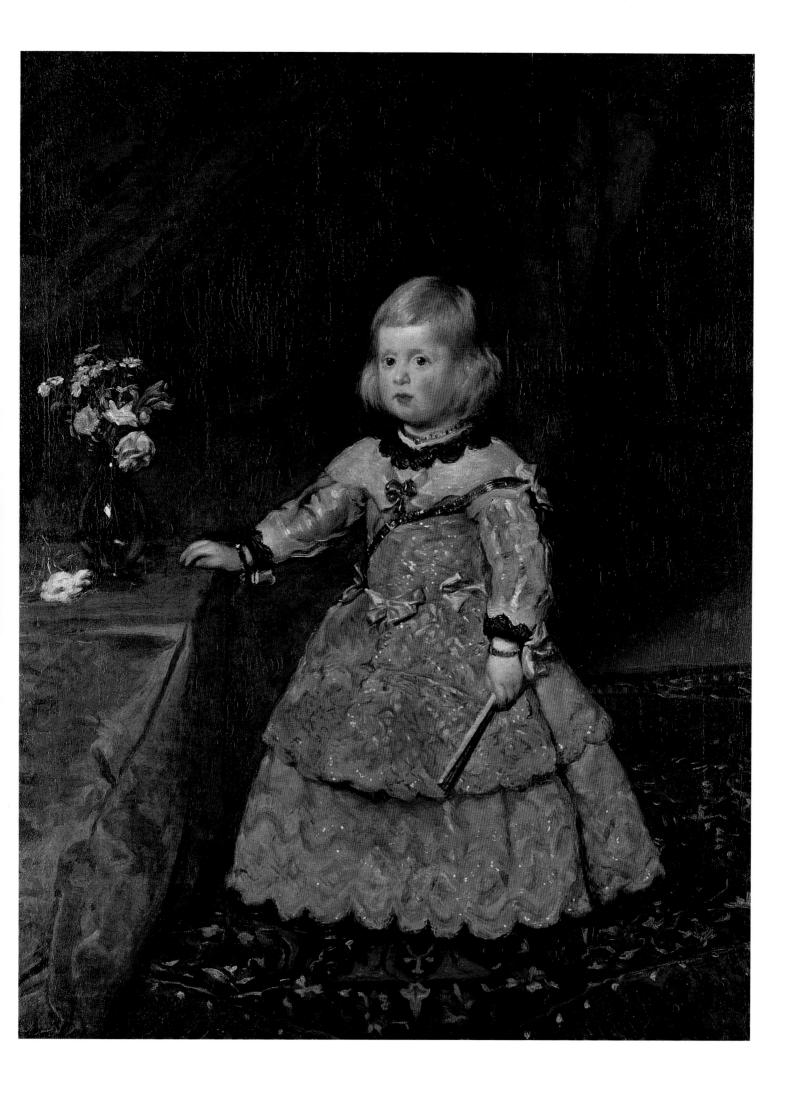

THE MAIDS OF HONOR
(LAS MENINAS)

1656

Oil on canvas, 10′ 5 1/2″ × 9′ 1″

Provenance: El Alcázar, Madrid (inventories of 1666, 1686, 1700); New Palacio Real, Madrid (inventories of 1772, 1794, 1814); (since 1819) Museo del Prado, Madrid (no. 1174).

Completed in 1656, this painting is universally acknowledged to be Velázquez's masterpiece. The inventories that listed it in 1666 referred to the work as *El Cuadro de la Familia,* or *The Royal Family.* Its current name of *Las Meninas* originated in the nineteenth century; the word *menina* is actually of Portuguese derivation and means "maid of honor."

The identity of the figures has been firmly established. Beginning with the artist himself, who is seen standing to the left before his easel, they are (from left to right): Doña María Augustina de Sarmiento; the Infanta Margarita (not the Infanta María Teresa, as was previously believed); Doña Isabel de Velasco (with Doña María Augustina, maids of honor to the young Infanta); the dwarfs Maribárbola and Nicolasito Pertusato, whose left foot rests on the dog lying on the floor in the foreground. Behind them, at the right, are two standing figures: Doña Marcela de Ulloa, attendant to the queen's ladies-in-waiting, and (?)Don Diego Ruiz de Azcona (less easily identified because his face is in shadow). In the background, enframed by the open door, is Don José Nieto Velázquez, palace chamberlain and, presumably, a relative of the artist. Finally, there is a mirror alongside the door, almost at the center of the canvas, which contains the reflected images of Queen Mariana and King Philip IV who are posing for Velázquez. The two paintings hanging above the mirror—probably the work of del Mazo—depict mythological scenes: *Pallas and Arachne,* after Rubens, and *Apollo and Marsyas,* after Jacob Jordaens.

This vast composition was already deemed an incomparable artistic achievement in the seventeenth century. According to Palomino, upon viewing this work in 1692, thirty years after the death of Velázquez, the Neapolitan painter Luca Giordano was said to have exclaimed, "This is the theology of painting!" Over a century later, the French Romantic writer Théophile Gautier, struck by the depth of this "cube in perspective," asked, "But where is the painting?"

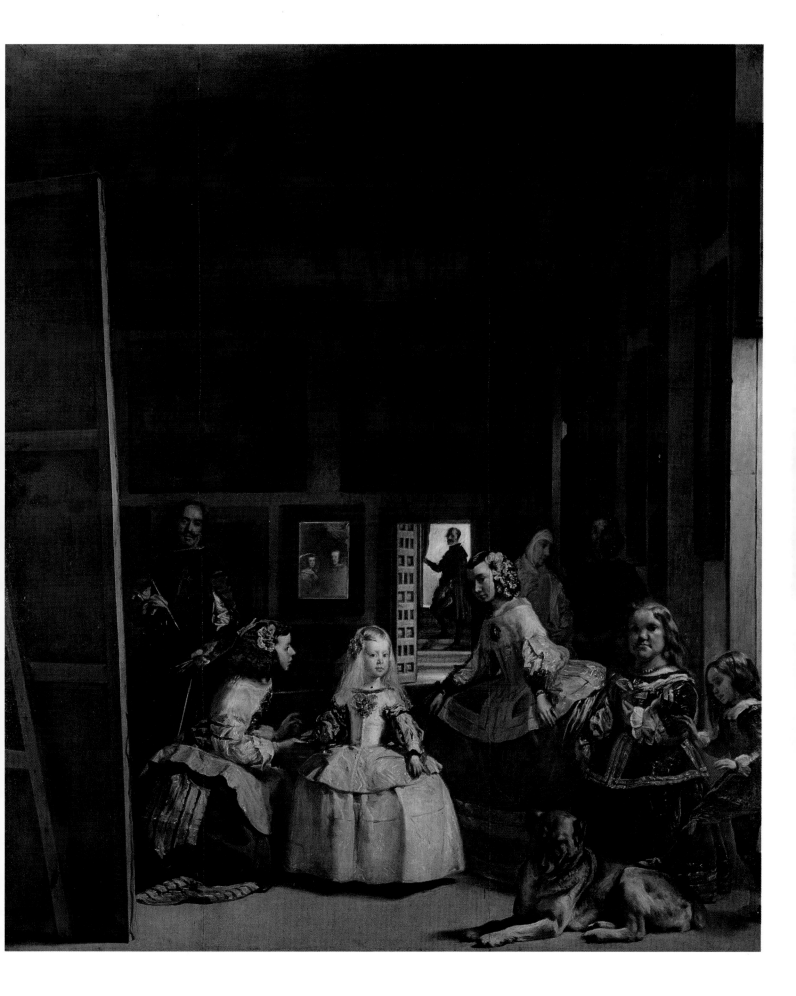

THE MAIDS OF HONOR
(LAS MENINAS), detail

Velázquez was one of those rare artists endowed with the ability to create subtle yet accurate portraits of children. As this detail from *Las Meninas* clearly demonstrates, the head of the Infanta Margarita is considered one of the high points of his art. Velázquez's tradition was perpetuated in the nineteenth century by his ardent admirer, Renoir, who must have reacted enthusiastically upon viewing a small portrait of the same Infanta Margarita in the Louvre (then considered an authentic Velázquez, but regarded as a studio copy today).

Despite their slightly stiff and formal appearance, one can detect a kind of mysterious complicity and a tender intimacy underlying the attitude of deep respect of the maid of honor, Doña María Augustina de Sarmiento, and in that of the young Infanta.

The mirror and the open door were devices frequently employed by the artist to extend the scene and give it an added dimension; they enabled him to carry the action depicted on the canvas even beyond the frame, so to speak, thus allowing the spectator to daydream over the subject, and to virtually become a participant in palace life.

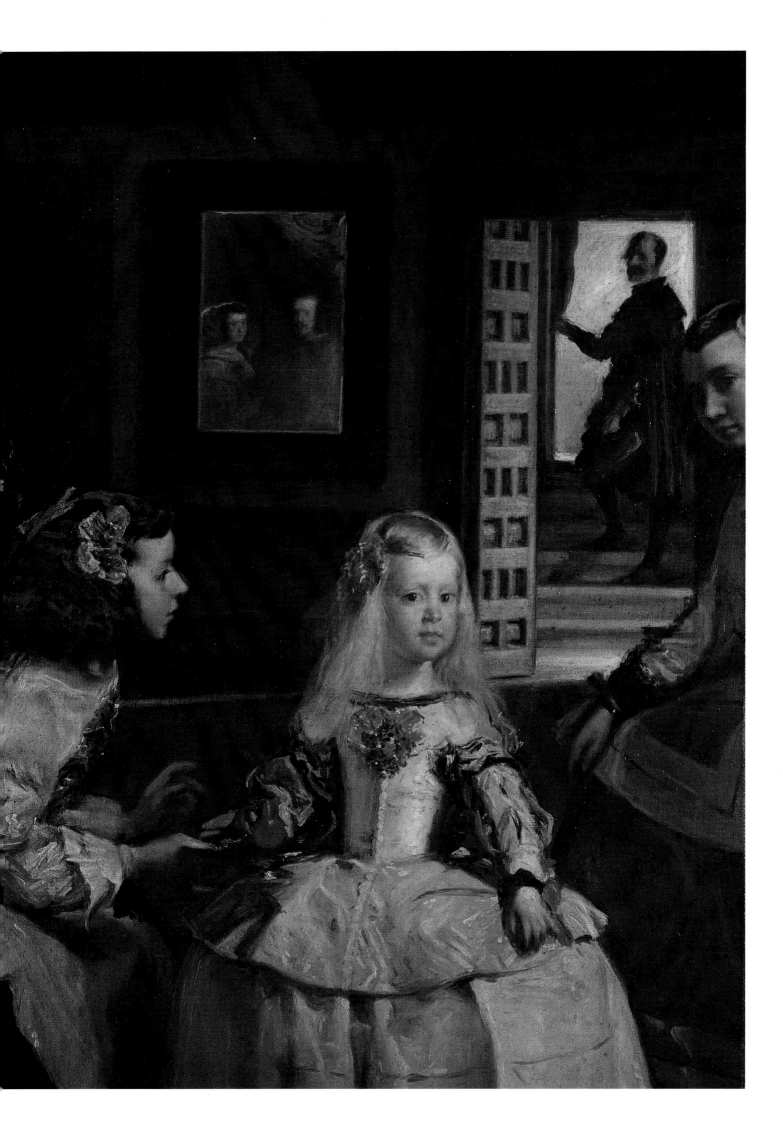

THE SPINNERS (LAS HILANDERAS), or THE FABLE OF ARACHNE

c. 1657

Oil on canvas, 7' 2 7/8" × 9' 2 1/2"

Provenance: Don Pedro de Arce, Madrid (inventory of 1664; the dimensions of the painting were significantly reduced [75 3/4 × 98 3/8"], and it was later enlarged by adding strips); royal collections, Madrid: probably bought by King Philip V, since it is not listed in the previous inventories of 1665 or 1700 of the Palacio Real; (from 1734) El Alcázar, Madrid; Palacio Real del Buen Retiro, New Palacio Real, Madrid (inventories of 1772, 1794); (since 1819) Museo del Prado, Madrid (no. 1173).

We share the opinion of the majority of art historians who date this work about 1657 on the basis of its style and the Italian influences that are easily discernible in the painting. A small group of critics, however, including López-Rey, prefer a date sometime between 1644 and 1650.

Until fairly recently, this painting was entitled *The Tapestry Factory of Santa Isabel in Madrid* and was popularly known as *The Spinners*. However, in 1948, Diego Angulo Iñíguez pointed out a connection between Velázquez's depiction of the scene and the myth of Arachne (in the inventory of 1664 there is a reference to the *Fabula de aragne*). According to the legend, Pallas Athena, the goddess who presided over the arts of needlework and tapestry weaving, was challenged and surpassed by her pupil, the young Lydian girl Arachne. When the angered goddess tore to shreds Arachne's series of woven tapestries of the loves of the gods—the first one depicting *The Rape of Europa*—Arachne hanged herself in despair, and was transformed by Athena into a spider.

Some see in the figures at work in the foreground an allusion to the three Fates. On the other hand, the hypothesis of Angulo Iñíguez and Charles de Tolnay that the workers in Velázquez's canvas represent the characters in the legend, and that the painter's source of inspiration was Ovid's *Metamorphoses* (Book IV)—a copy of which was in Velázquez's library—seems more plausible. Thus the young woman winding on the wool at the right would be Arachne; the old woman at the spinning wheel would be Athena, as she appeared before revealing her true nature. In the background of the painting, through the device of "simultaneous episodes," the second part of the myth enfolds: in front of Arachne's tapestry depicting *The Rape of Europa* (in what seems to be an upper room or a small stage), the helmeted Athena appears before the headstrong Arachne in full armor.

Velázquez's presentation of *The Rape of Europa* is taken directly from a painting by Titian, a fact that further complicates what is an already complex scene.

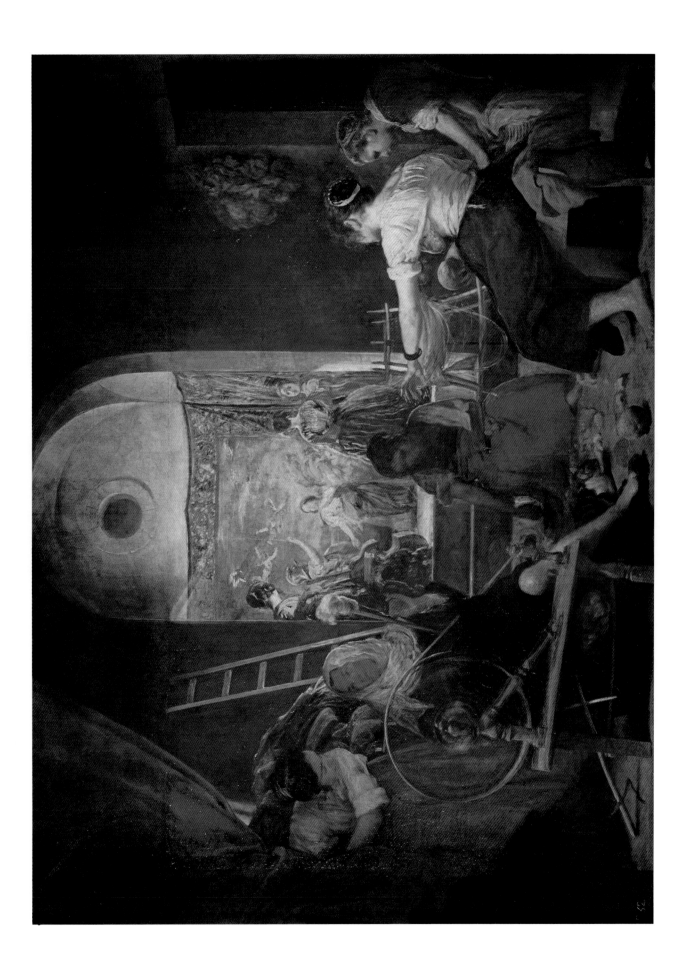

THE SPINNERS (LAS HILANDERAS),
or THE FABLE OF ARACHNE, detail

In this masterpiece Velázquez concurrently draws upon illusion and mythology, allegorical meaning and reality; for the latter, the artist seeks sensitive models and clever ideas. In *The Spinners* we witness the union of idea and craft that is the essence of Art, and it should be emphasized that, for Velázquez, Art and Craft—the two groups under Athena's domain—are inextricably linked, in theory as in practice. Renoir, who held Velázquez in the highest esteem, in effect espoused this theory in his Preface to the 1911 edition of the *Libro dell'Arte* of Cennino Cennini (c. 1390), and affirmed that "*Painting is a craft* and is subject to the same rules that govern carpentry and ironworking. . . ."

On the purely pictorial level, the outstanding feature of this work is, once again, the spots of color deftly applied in small, rapid brushstrokes that are the hallmark of Velázquez's prodigious technique. Furthermore, specialists such as Bardi have noted, as we have, that "certain technical solutions anticipate Impressionism, Pointillism, and other pictorial styles that were linked to discoveries in optics which sounded the death knell of the continuous line." He reminds us that Velázquez painted during the age of Galileo, Hans Lippershey, and Zacharias Jansen (the latter two Dutchmen were microscope inventors), and other specialists in the problems of light.

In terms of reality and the honest portrayal of the figures, those in the foreground working in semi-darkness—especially the woman at the left, near the spinning wheel (reproduced in this detail)—once again demonstrate the close relationship between Spanish painting and the picaresque novel of the Golden Age.

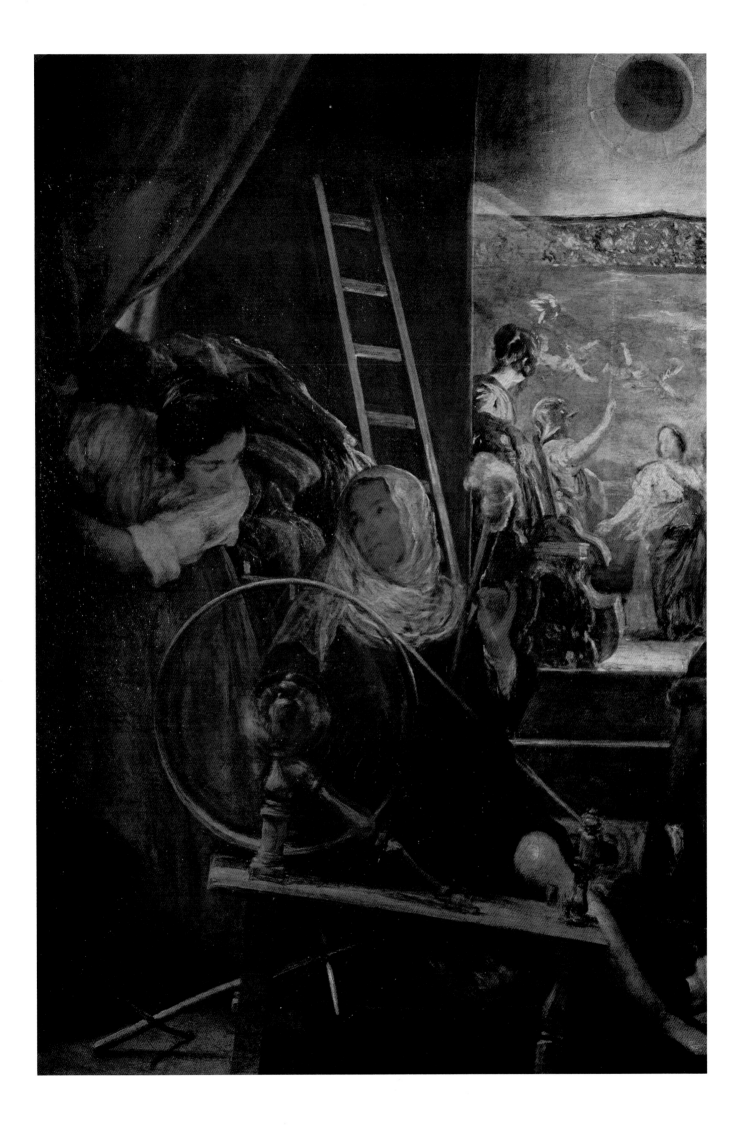

MERCURY AND ARGUS

1659

Oil on canvas, 50 × 97 7/ 8"

Provenance: Hall of Mirrors, El Alcázar, Madrid (inventories of 1666, 1686, 1700); New Palacio Real, Madrid (inventories of 1772, 1794); (since 1819) Museo del Prado, Madrid (no. 1175).

This work is generally believed to date from 1659. The strips that are visible at the top and bottom of the canvas were added to repair the damage suffered by the painting during the fire of 1734.

According to the myth, Argus was a prince from the Peloponnesian city of Argos who had one hundred eyes. Since fifty of them were open at any given moment, Juno ordered him to stand guard over the young Io, who had been seduced by Jupiter and then changed into a cow. Mercury, sent by Jupiter, lulled Argus to sleep with the sound of his flute, and then he cut off Argus' head (or stoned him to death). Juno scattered the eyes of the slain Argus on the tail of a peacock, after which the bird was devoted to the goddess.

Here again, Velázquez transforms a mythological and supernatural event into a realistic scene with such overpowering truthfulness that it seems more appropriate to a picaresque novel than to a legend from antiquity. The two protagonists of this genre scene transport us directly into the world of the *picaro* —of *La Vida de Lazarillo de Tormes,* or of Cervantes' *Don Quixote* and *Novelas ejemplares.* The pauperism in Spain during the so-called Golden Age and the hunger that was a major preoccupation of the people fostered the prevalence of vagabonds who played a prominent role in everyday Spanish life. However, although "pilfering" held a special place of honor, comical pranks and abominable tricks played on blind men also frequently found their way into these picaresque novels. Like the writers and poets who were his contemporaries, Velázquez utilized his genius to become a pictorial chronicler of the times, by virtue of his incomparable brush instead of the pen.

Justi believes that Argus' legs were inspired by the sculpture of the *Dying Gaul* that Velázquez may have seen in Rome, while de Tolnay sees in Argus' body a similarity in pose and execution to the nude youth at the right above Ezekiel on the ceiling of the Sistine Chapel.

The extreme technical fluidity with which the work was conceived, especially the device of lighting from behind and the sensitive chiaroscuro effects, heightens its realism while, at the same time, infusing it with poetry.

THE INFANTA MARGARITA
IN A BLUE DRESS

1659

Oil on canvas, 50 1/4 × 42 3/8"

Provenance: Together with Prince Felipe Próspero, *sent in 1659 as a gift to Emperor Leopold I (Hofburg, Vienna); Kunsthistorisches Museum, Vienna (no. 2130).*

This portrait, dating from 1659, which shows the young Infanta Margarita at the age of eight, was once believed lost. In 1923, it was discovered—cut down to an oval, probably during the eighteenth century—in the storeroom of the Kunsthistorisches Museum in Vienna. Careful but major restoration in 1953 returned the painting to its original dimensions.

This work reveals the diversity of Velázquez's talent and style as a portraitist. Indeed, the roughly sketched-in right hand, barely visible in the shadow, as well as the sleeve of the dress are not that far removed in terms of technique from the style of Frans Hals, Velázquez's Dutch contemporary, or the art of Édouard Manet. However, the freer treatment of the face and the more finished left hand are reminiscent of Renoir.

The beauty of the formal dress, with its reflections of light, its shadows, and rich surfaces; the silver-gilt braid that sets off the deep blue of the velvety fabric; the dark brown tones of the right portion of the canvas; and finally the long chain, golden like the young Infanta's hair—all these elements combined proclaim not only Velázquez's exceptional gift for painting but, especially, his unique skill as a colorist.

Let us compare this portrait in particular with an unfinished work (Museo del Prado) doubtless executed in large part by Velázquez's son-in-law, Juan Bautista del Mazo, showing the Infanta Margarita at about the same age (fig. 50). The overall color scheme is dominated by variations of subtly shaded reds, as well as whites, grays, and a few gold highlights provided by the jewelry. Velázquez's deliberate choice (sometimes adopted by del Mazo) of a single, dominant color, which he elaborates upon by developing delicate gradations with extreme refinement, brings to mind the variations upon a single musical theme by Mozart and other composers of genius.

(There is also an extant studio copy of this painting, not by Velázquez, which was originally in Vienna and is now in Budapest, in which the Infanta's dress is green instead of blue.)

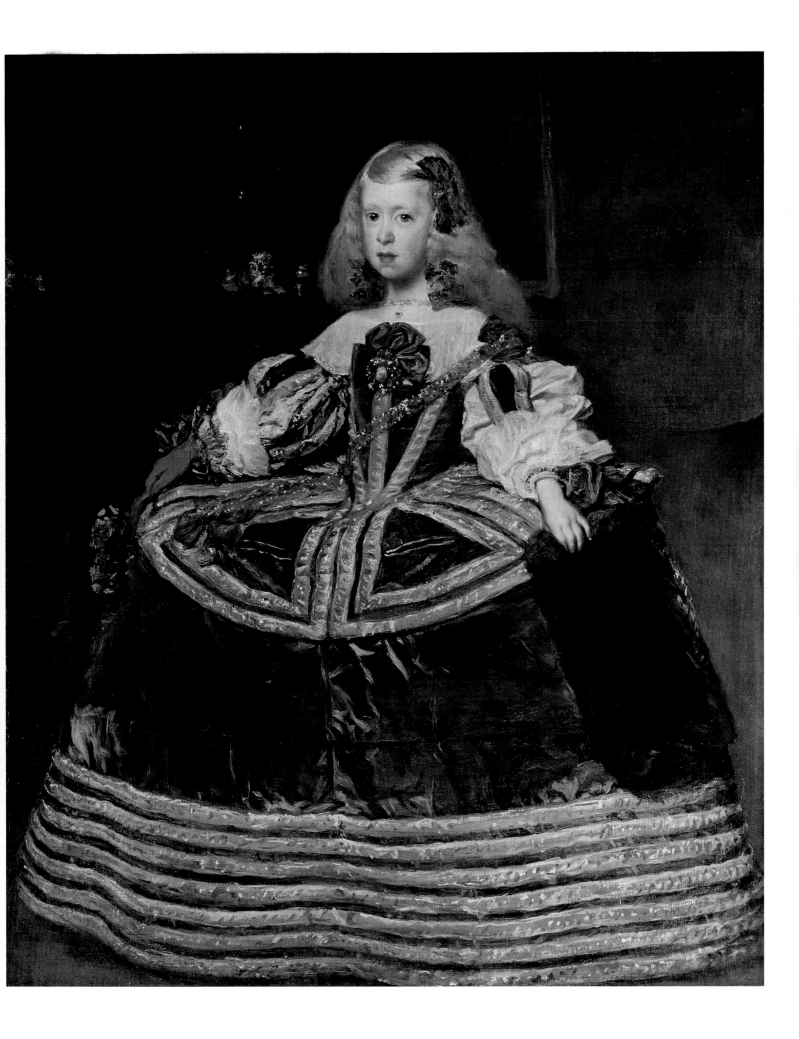

PHOTOGRAPH CREDITS

Note: Numbers refer to figures, and an asterisk (*) denotes a colorplate

The author and publisher wish to thank the libraries and museums for permitting the reproduction of works in their collections. Photographs have been supplied by the owners or custodians of the works of art except for the following, whose courtesy is gratefully acknowledged:

Annan, Glasgow: 2; Ludovico Canali, Rome: *28; Geoffrey Clements, New York: *27; Clichés des Musées Nationaux, Paris: 37, 38; A. Dingjan, The Hague: 10; Lauros-Giraudon, Paris: 16; MAS, Barcelona: 7, 8, *8, 9, *10, 15, 17, 19, 20, 21, 22, 23, 24, 25, 26, 27, 28, 29, 30, 31, 32, 33, 35, 36, 40, 41, 42, frontispiece, 43, 45, 46, 48, 49, 50, 51; Erwin Meyer, Vienna: *34, *40; Tom Scott, Edinburgh: *1; Walter Steinkopf, Berlin-Dahlem: 1; Victoria and Albert Museum, London: 6; John Webb, London: *2, *3, *5, *9, *17, *33.